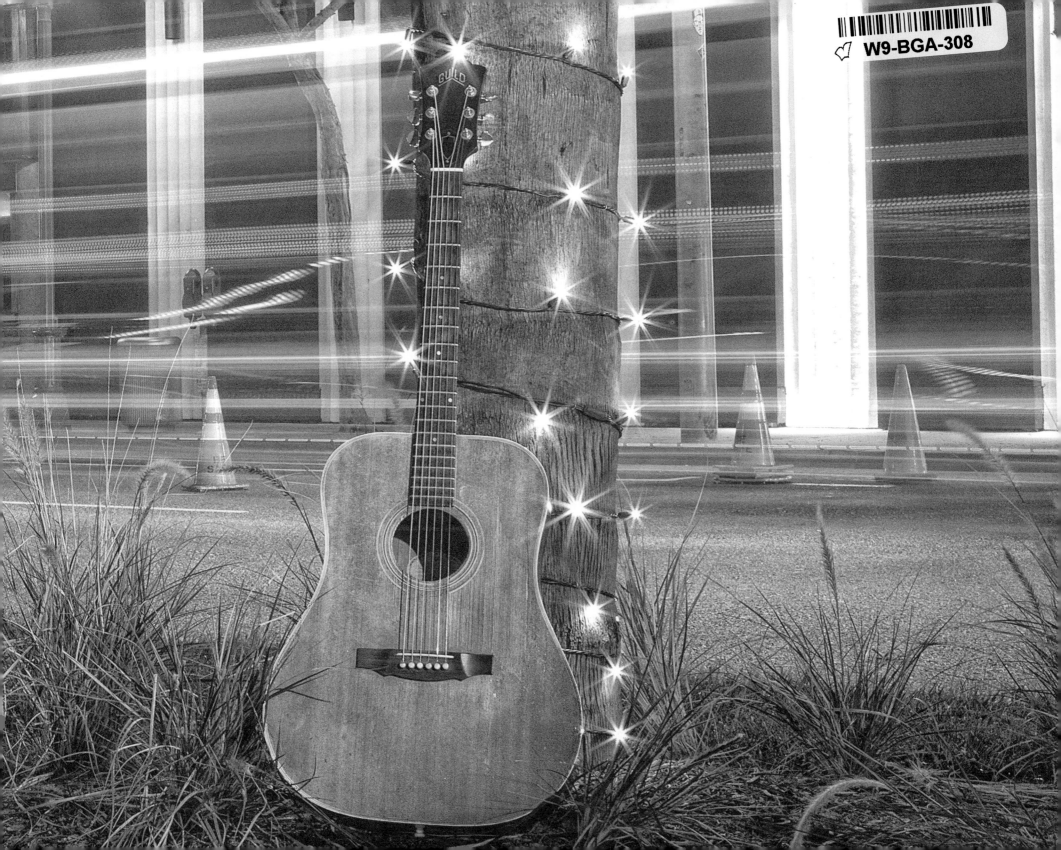

"This is a beautiful book—beautiful for its photographs, the words that take us on a magical journey, and the deep emotions it evokes. Like a good guitar in the hands of a talented guitarist, this book creates tunes and melodies for the mind. It plucks our heartstrings and revives memories of our life and times. You don't have to know music to appreciate this terrific book, with a well-told story the bonus to its colorful photographs."

Dan Rather
Anchor and Managing Editor, *Dan Rather Reports*

"If you like guitars, you're going to love this book! Stephen Arnold's guitar collection shines through Chris Fritchie's beautiful photography in *A Story of Six Strings*. The combination of cool guitars, brilliant photography, and funny stories makes this one of the best guitar books I've seen. And Stephen, to answer your question, 'Who really has their first guitar?' I do. Cheers!"

Steve Miller
The Steve Miller Band

"This book took me way back. I grew up playing in garage bands and was familiar with, but had forgotten about, some of the great old guitars in this terrific book. It was fun to see them again in wonderful settings, captured by amazing photography. I sure hope they didn't leave that Olson out in the snow too long!"

Jim Olson
Luthier, James A. Olson Guitars

"This is a memorable anthology that spans decade after decade of personal and professional experiences. Pairing each instrument with an appropriate landscape to help paint a visual picture and tell a compelling story helps bring the guitars to life. Terrific photographs—truly an enjoyable series of shots."

David Woo
Photojournalist, *Dallas Morning News*, Two-Time Pulitzer Prize Finalist

"In sixth grade, Stephen was the hottest, hippest lead guitarist at Armstrong Elementary in Dallas, Texas. He played the meanest version of 'Johnny Be Goode' and 'Wipe Out' we had ever heard. As for the book, the guitars and other vintage instruments, photographed so creatively, are beautiful works of art…even when quiet."

Trammell S. Crow

"The same artistry and innovation that Stephen brings to creating musical signatures for our television stations can be found in *A Story of Six Strings*. This entertaining book is distinctive…a longstanding trademark of Stephen Arnold Music."

Perry A. Sook
Chairman/CEO/President, Nexstar Broadcasting Group, Inc.

"I remember the first time Stephen came to Atlanta as we were about to rebrand the Weather Channel. He played four simple notes that would become our new musical logo—our sonic brand. Simplicity can be incredibly powerful. Reading *A Story of Six Strings*, with all the wonderful photos and stories behind the guitars, provided inspiration and insight into the gifted artist I feel fortunate to have known and worked with."

Rick Booth
Former Vice President/Creative Director, The Weather Channel

"When he was getting started, Stephen used to come to me with a beat-up guitar, strum a few chords, play a melody, and say, 'I need you to make that work with twelve violins, four violas, a couple of cellos, three trumpets, three trombones, and a pair of French horns. Do you know a harpist? And by the way, the session is tomorrow.' Those were the days. What a treat it is to create complex orchestrations from simple melodies created on a guitar and to see those instruments brilliantly photographed."

Paris Rutherford
Regents Professor Emeritus, jazz studies, The University of North Texas

"Stephen and I wrote our first song together back in 1988 for the New Orleans Saints and have teamed up writing music ever since. We have lugged our guitars from Nashville to Dallas, Austin to Los Angeles, back to New Orleans, and even to Cannes, France. Seeing these guitars shot so beautifully across the US, all in one book, makes it truly a story of six strings."

Greg Barnhill
Emmy-winning, Grammy-nominated singer and songwriter

A Story of Six Strings

```
E---------------------------------------------------------------------------------
B-----------10~--------8(~)--(8)h10-----------------------------------------------
G-----------------------------------------10~-------10-------9(~)--(9)h10--7~------
D--------10---------10-------------------------------10-----10---------------------
A--/8-----------------------------------------------------------------------------
E---------------------------------------------------------------------------------
```

written by
Stephen Arnold

with photography by
Chris Fritchie

Brown Books Publishing Group
Dallas, Texas

A Story of Six Strings

Brown Books Publishing Group
16250 Knoll Trail Drive, Suite 205
Dallas, Texas 75248
www.BrownBooks.com
(972) 381-0009

ISBN 978-1-612547-95-4
Library of Congress Control Number 2011942667

Printed in the United States of America
10 9 8 7 6 5 4 3 2 1

For more information,
please visit www.stephenarnoldmusic.com.

A very special thank you...

```
E-----------------------------------------------------------------------|
B-----------10~-------8(~)--(8)h10-------------------------------------|
G-----------------------------------10~------10-------9(~)--(9)h10--7~---|
D-------10----------10-------------------10-----10---------------------|
A--/8-----------------------------------------------------------------|
E-----------------------------------------------------------------------|
```

To Dave Muscari at WFAA for his creative copywriting and continual insight; Chad Cook, our creative director, by my side and covering my back for twenty years; Ray Lambiase at FOX Business Network, an outstanding art director and an even better singer-songwriter; Dee Joyce at WPIX, who pushed the creative envelope producing some of the best music I have ever written; Annette Hermann, who while working at KXAS saw beyond my pedestrian, sixty-second jingles and fortuitously introduced me to the world of television music; Greg Barnhill, a prolific singer-songwriter with an incredible heart; JT Cantwell and Bob Bates at CNN, who believed and embraced a small time composer from Texas almost two decades ago; my brother, Bob, who sold my inaugural television news package; my amazing wife and biggest fan, Carol, who continues to put up with my up-all-night life; my children, Whitney, Stephen, Anna, and Lyle; and of course my mom and dad, for that first Sears guitar and those twelve long, hard years of classical piano lessons forced on me at gunpoint.

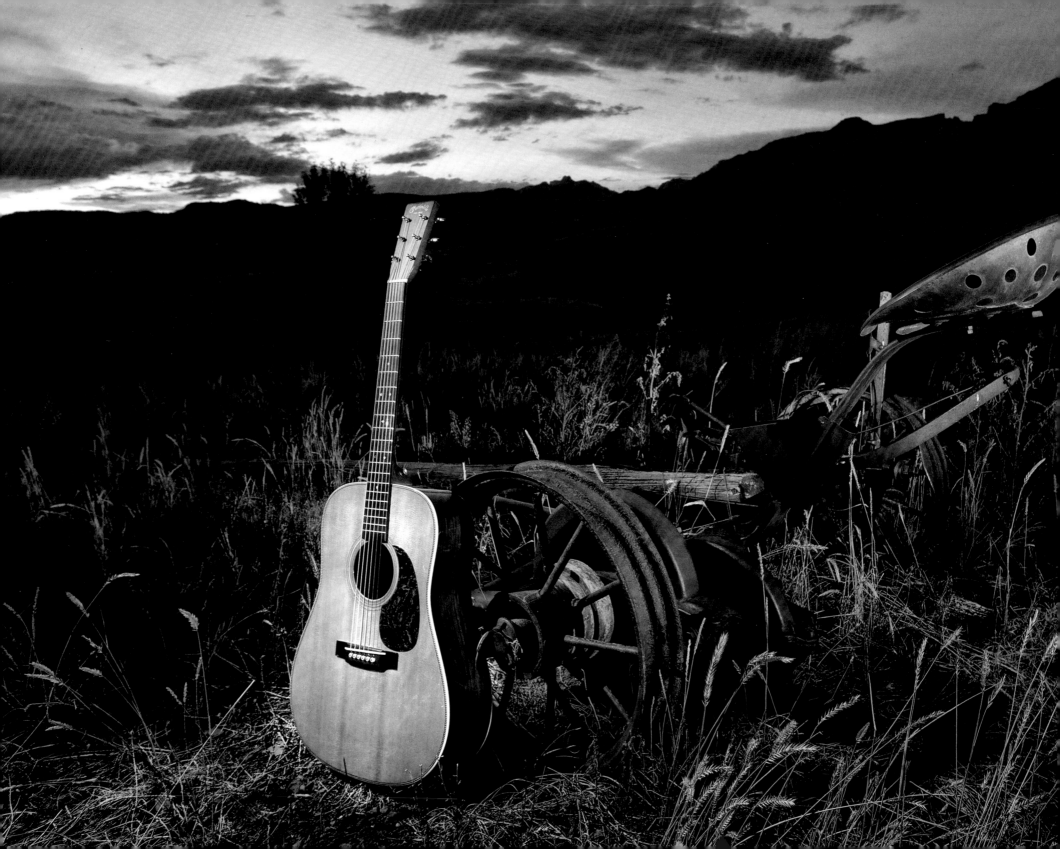

Contents

ix Foreword

xi Author's Note

1 In the Beginning

2 My Favorite Martin

5 Miss Texas

7 Snap, Crackle, Pop . . . Tony Rice

8 Parlor Guitar

10 Everything You Need: $67.95

13 I Saved This Guitar's Life

14 James Taylor's Back Scratches

16 Remember the Alamo

18 Little Daddy

21 Onstage at America's Biggest State Fair

22 Louie the 54th

25 "This is CNN."

27 Turn! Turn! Turn!

29 Ground Zero: Ten Years Later

31 Retro Mania

32 Mondays at the Troubadour

35 God Bless Louisiana

36 An Uncommon Cure for a Common Case of Writer's Block

39 Daddy's Girl

40 Django

43 Blues Power

45 Seven to Seventeen

47 Jingle-Jangle

48 Meet the Fifth Beatle

51 Born on Broadway

52 It's Only Rock 'n' Roll

54 Crossroads

57 Garage Bands Rule

58 Two-Headed Gothic Monster

61 12-String Versus 6-String

62 Amanpour

65 Twin Sons of Different Mothers

66 Transcendent Power of Music

69 Indestructible

70 Prime Time

72 Half-and-Half

74 Standing Ovation

77 Got to Get You Into My Life

78 A Rusty Bolt and String

80 Free Food and All the Music You Can Stand

82 Place of Honor

85 Coyote Lullaby

87 17 Strings, 12 Bells, and a Super Bad Bow

88 Billy

91 Roll Tape

92 My Turn

95 Two-Week "Paid Vacation" in the Middle of Nowhere

96 Plug Me Into Something

99 The Log

101 The New Kid in Town

103 Cut to the Chase

Acknowledgments

About the Photographer

About the Author

Foreword

```
E--------------------------------------------------------------------------|
B-----------10~-------8(~)--(8)h10----------------------------------------|
G---------------------------------10~-----10-------9(~)--(9)h10--7~---|
D-------10--------10----------------------10-----10----------------------|
A--/8---------------------------------------------------------------------|
E--------------------------------------------------------------------------|
```

Sound carries. Strings vibrate and melodies take us back to other times and places. This book is about guitars that stand firm—older but unchanged by their travel through time.

The photographs in this book place the personalities of the instruments in context—both unique to Stephen Arnold and as part of a broader journey through the American heartland.

I first met Stephen across a conference table in Atlanta more than a decade ago when I was the creative director at CNN. He had traveled to Georgia from Texas and I had come from New York City.

Our individual paths intersected that day at the sound of his acoustic guitar ringing behind an unusual mix of orchestration and world beat. I had begun my own career as a musician and a songwriter, and I recognized the shared highway at once.

Years later when I had the opportunity to commission music for Peter Jenning's *In Search of America*—a documentary series highlighted in this book—I turned to Stephen and his six-string guitar. Finding a theme to capture the fabric of our national story would take someone who understood these things.

The photos that follow honor the distance between instruments and the ripples in the air they leave behind—between guitars and the ever-changing landscape of the music they produce.

But more importantly, this book celebrates the common ground between the artist and the listener—and the reader who will find their own memories resonating in these pages.

—Ray Lambiase
Veteran Broadcasting Creative Director
October 2011

Author's Note

```
E-----------------------------------------------------------------------------------|
B-----------10~--------8(~)--(8)h10-------------------------------------------------|
G-----------------------------------------10~-------10-------9(~)--(9)h10--7~---|
D--------10-----------10-----------------------------10-----10----------------------|
A--/8-------------------------------------------------------------------------------|
E-----------------------------------------------------------------------------------|
```

There is nothing more moving than when the light pluck of a guitar string echoes the first few notes of a new melody. It's my hope that you will enjoy a bit of what has been an amazing journey for me—the guitars that have come into my life and allowed me to make music for people to enjoy, recognize, and remember. They range from a few of the finest instruments ever made to some simple finds.

My passage began over forty-five years ago, when my mom bought me a new 1959 Silvertone acoustic guitar straight out of the venerable Sears catalog. I have distinct memories about the first time I cautiously dragged my finger across the strings and immediately discovered a fiery passion to create something new. It is a desire that has never waned and still drives me to this day.

The implication of that single, uncomplicated movement can launch, as four young Englishmen once wrote, a "magical mystery tour" of sensations. The striking of a chord or the basic progression of a few random notes can be exhilarating, touching, distressing, invigorating, or spine-tingling. It creates a multiplicity of distinctive moods, has a dramatic effect on a variety of psychological and physiological behaviors, and is so emotionally evocative it can instantly modify nearly any human conduct.

Over the years, my supportive family, dear friends, and valued clients at television stations, broadcast and cable networks, advertising agencies, and other venues have all so graciously embraced my art. As a result, they allowed me the rare opportunity to live my distinct version of the American dream.

This book gives me a new way to share this musical journey with you. I hope you'll agree these amazing instruments are as beautiful to look at as they are to listen to.

—Stephen Arnold

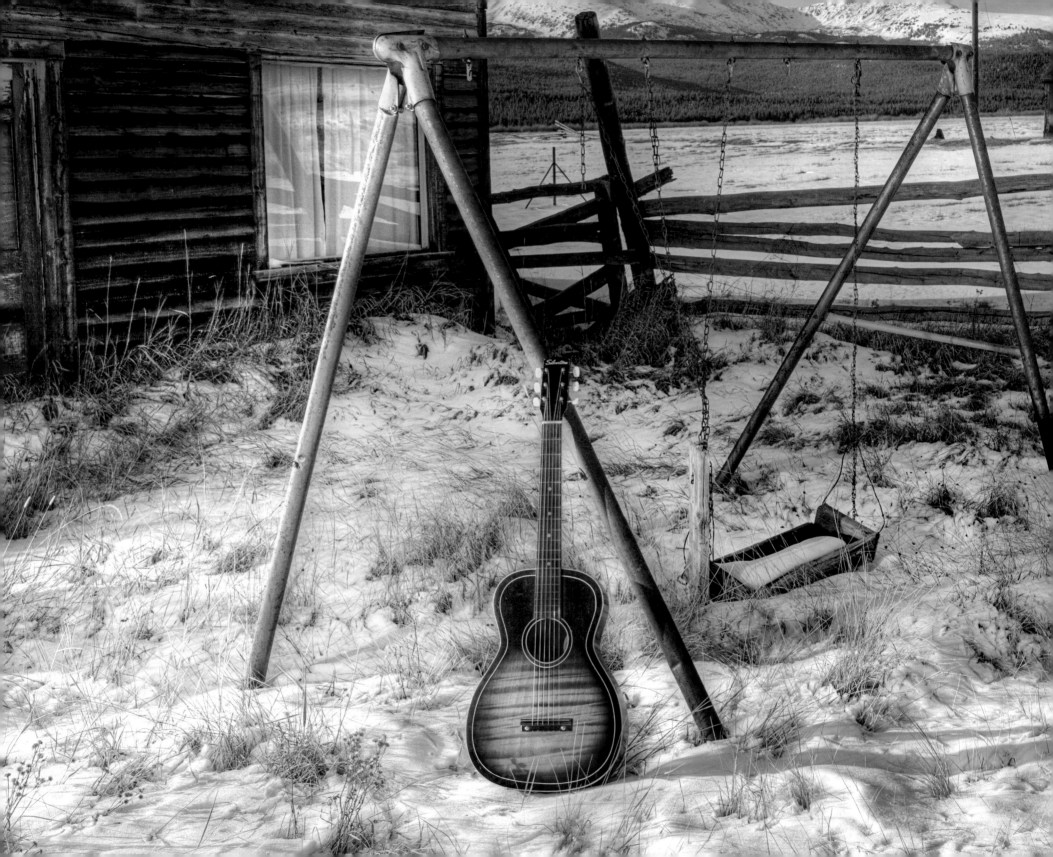

In the Beginning
1959 Sears Silvertone Acoustic

For some people it is their first bicycle, skateboard, basketball, or piccolo. Everybody has to start somewhere, and in my case this is ground zero. The first guitar that my parents got for me was a 1959 Silvertone from the Sears catalog for $14.99. I was only seven when I wrote my first song on it, a one-note wonder I called "Mama Won't Let Me Play My Guitar No More."

An abandoned ranch just north of Leadville, Colorado

My Favorite Martin

1934 Martin 018

Once while serving as a close friend's best man in a wedding in North Carolina, we took a detour that nearly made us miss the whole event. The morning of the ceremony, the groom insisted on driving out to an old barn he had heard about located "somewhere in Carolina." It allegedly housed a massive stock of vintage Martin and Gibson guitars. The wedding started at 4:00 p.m., and we made it back with a whopping thirty minutes to spare, looking a bit worse for the wear. The marriage didn't last, but I still have the Martin I bought that day. My "wedding guitar" rings like a bell and has been pushed into service many times since then, appearing on dozens of music packages.

A rusted-out Chevy truck in Frisco, Texas

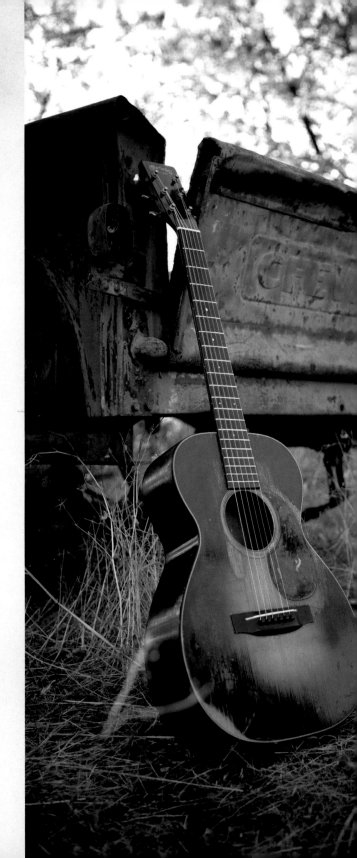

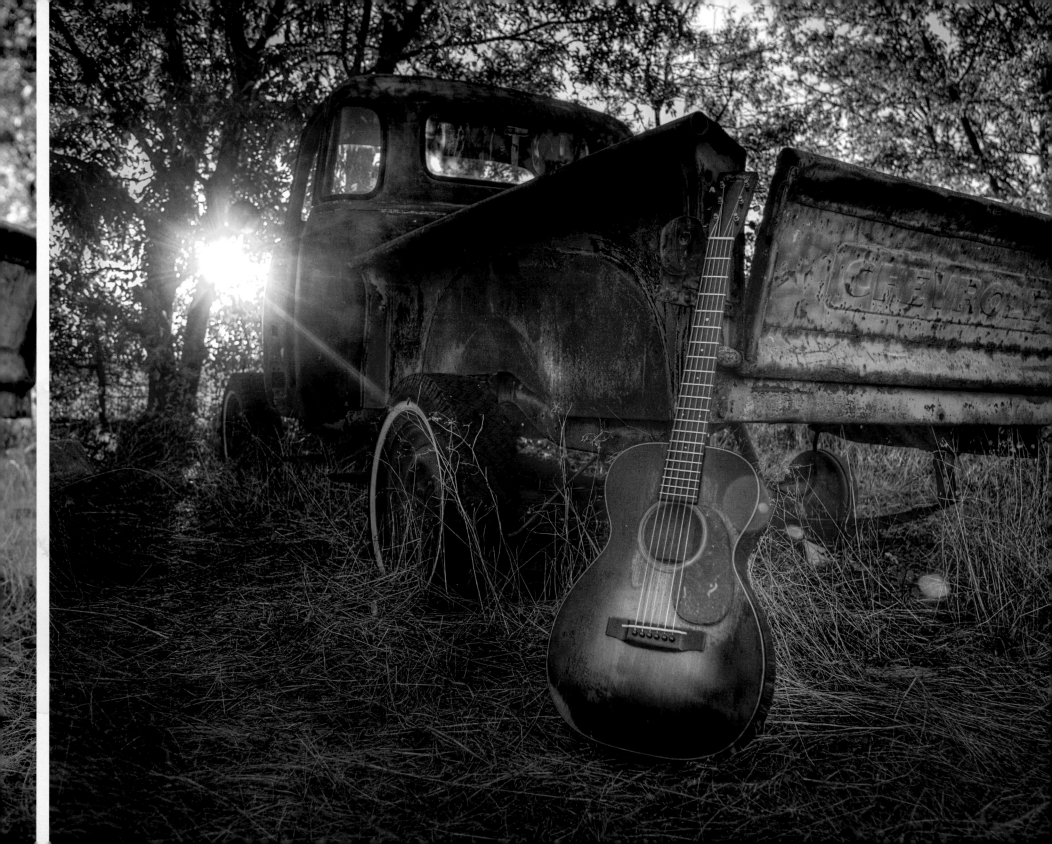

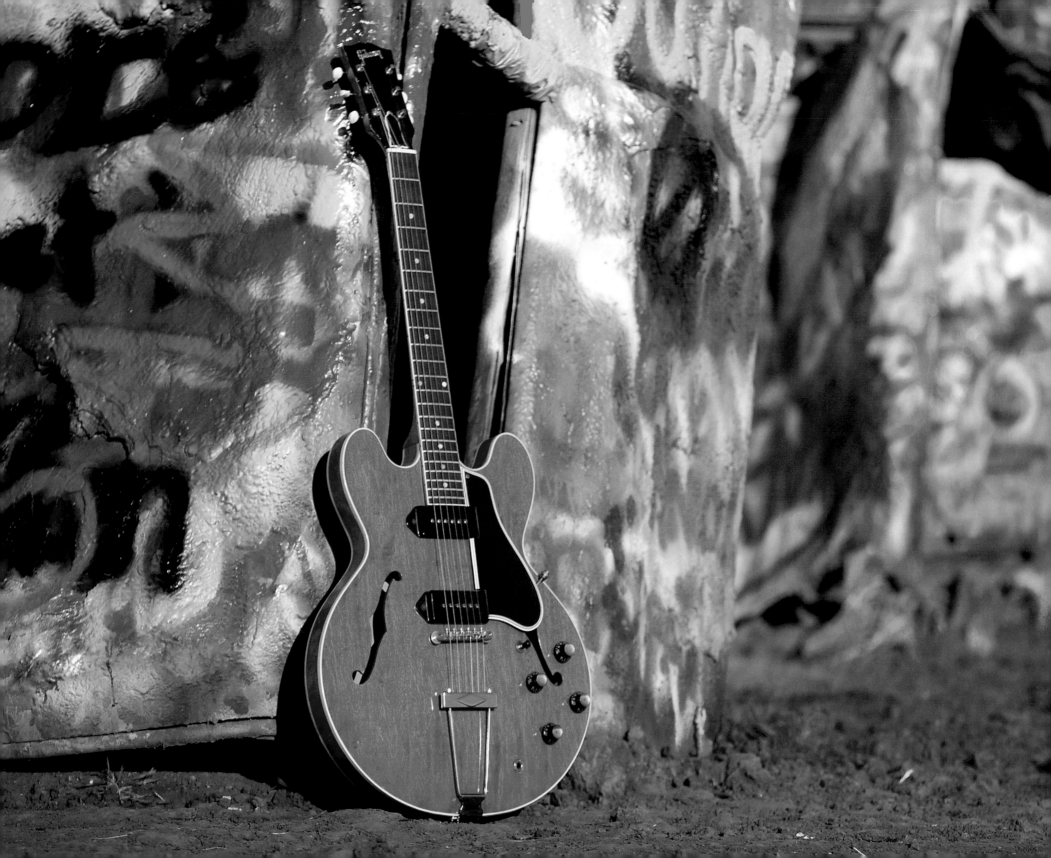

Miss Texas

1960 Gibson ES-330

This was my main guitar on my first trip to LA. I was working for Bellinda Myrick, a former Miss Texas who assumed her title after Phyllis George was named Miss America. She somehow wound up with her own musical revue, and I was her version of Letterman's Paul Shaffer. We thought we were headed to Vegas, but we ended up in Reno playing three shows a night to drunken gamblers. The Gibson 1960 ES-330 was "the poor boy's ES335" at the time. Take special notice of the black P-90 pickups instead of the fancier, dual coil humbucking pickups. Nevertheless, it is a terrific guitar that I still play on sessions three decades later.

Cadillac Ranch, west of
Amarillo, Texas, on Route 66

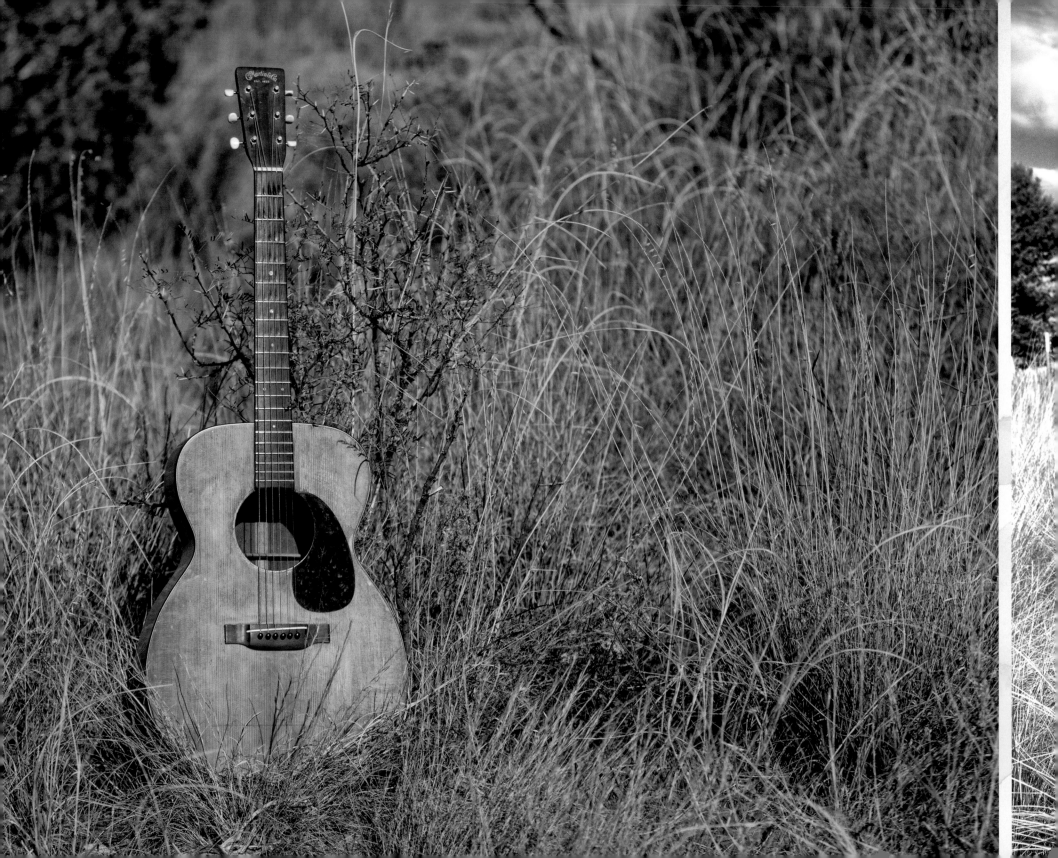

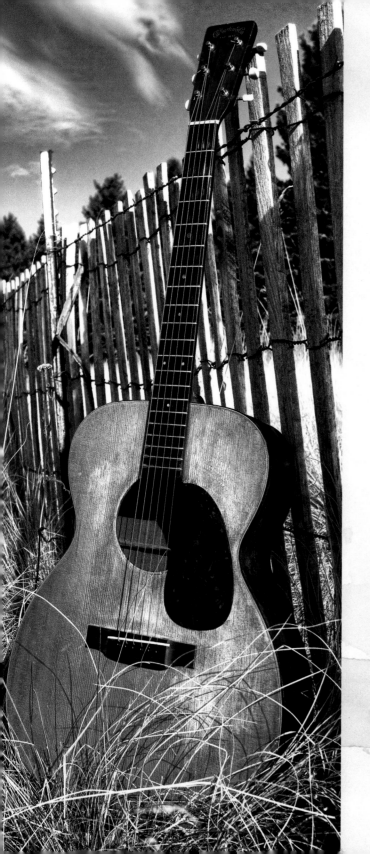

Snap, Crackle, Pop . . . Tony Rice

Pre-War 1942 Martin 000-18

Back in the 1980s a station in Tennessee asked me to hire progressive bluegrass guitarist Tony Rice to play on a promotional track. Our session ran long, and Tony said he needed to leave for a little while. He never returned. At 2:00 a.m. I received a phone call at my motel. It was Tony, telling me to meet him at a friend's house, who had an 8-track recorder, and we could finish up the session there. He showed up with a highly modified, pre World War II Martin D28 that he claimed to have bought from Clarence White of the Byrds. It had this enormous sound hole that made it especially loud. (I heard White used to put cigarettes out around the sound hole, others say he just played the crap out of it.) Later I bought this guitar and named it "Tony Rice" because of its enlarged sound hole. It has a bone-chilling bass response, especially the A and D strings.

Palo Duro Canyon State Park in Canyon, Texas
Bandelier National Park in Los Alamos, New Mexico

Parlor Guitar

1840 Nicolas Henry Original, made in Mirecourt, France

There's something brilliantly haunting about playing Brazilian jazz on a 160-year old French guitar. Originally these smaller body instruments were designed and produced during the mid-nineteenth century, bright in tone and often surprisingly loud. I found this 1840 Nicolas Henry guitar, which was made in Mirecourt, France, in a shop in Paris. After all these years, it still plays beautifully and has amazing intonation.

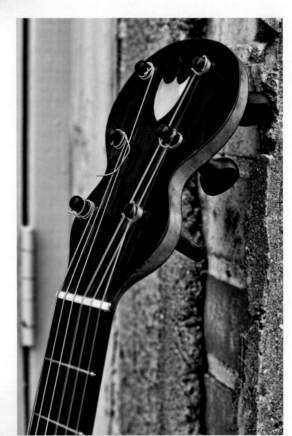

An alleyway just off the Plaza in Santa Fe, New Mexico
Cathedral Basilica of St. Francis of Assisi in downtown Santa Fe

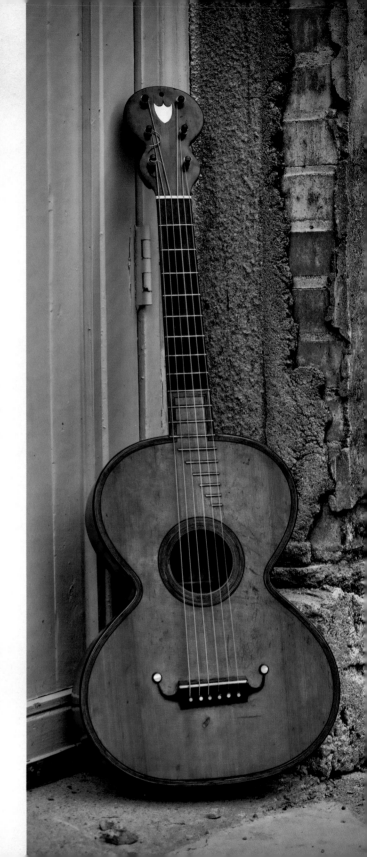

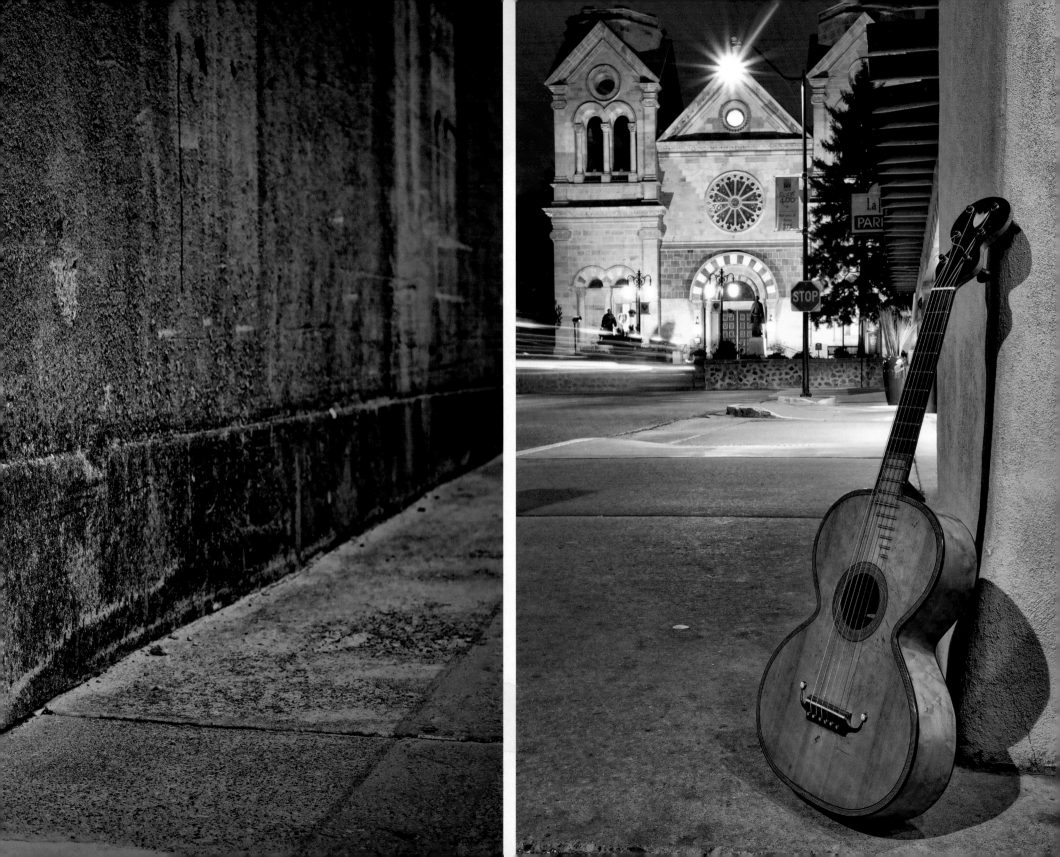

Everything You Need: $67.95

1962 Sears Silvertone Electric

I used to fall asleep at night with a transistor radio under my pillow and a Sears catalog on my bed, dreaming about a Silvertone electric guitar. Hearing that guitar blasting from a speaker is a sensation I will never forget. As for the amplifier, it had three tubes, a nice, warm sound, and—wouldn't you know it—all these years later it still works like a charm.

Cadillac Ranch, west of Amarillo, Texas, on Route 66
An advertisement for the Silvertone Electric from a 1962 Sears catalog

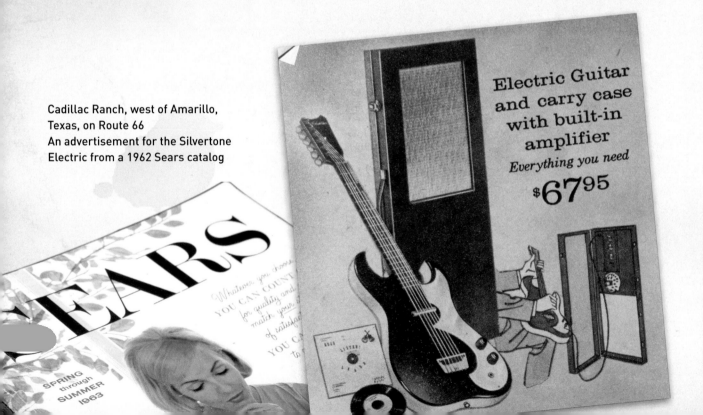

Electric Guitar and carry case with built-in amplifier
Everything you need
$67^{95}

SEARS

Whatever you choose, YOU CAN COUNT for quality and match your of satisfaction YOU CA to

SPRING through SUMMER 1963

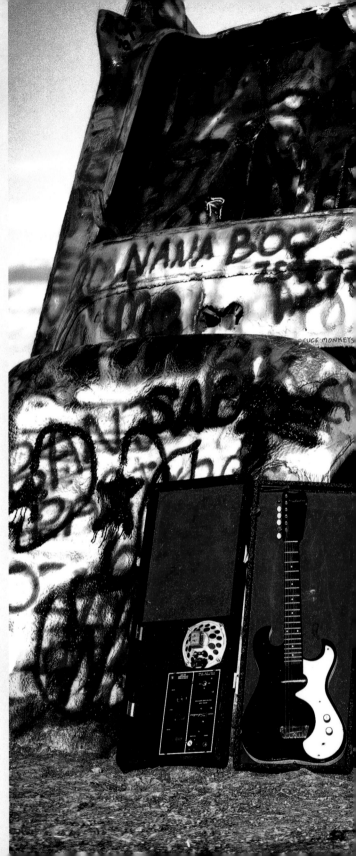

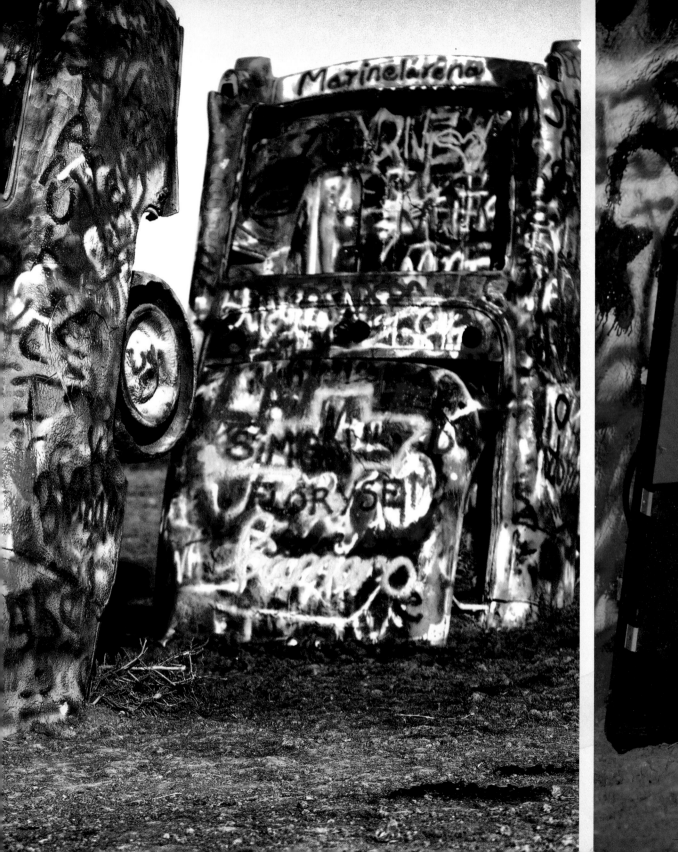
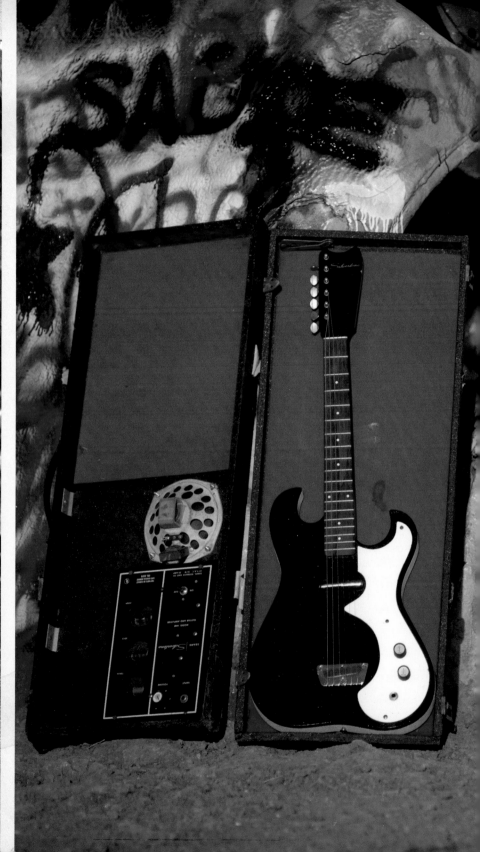

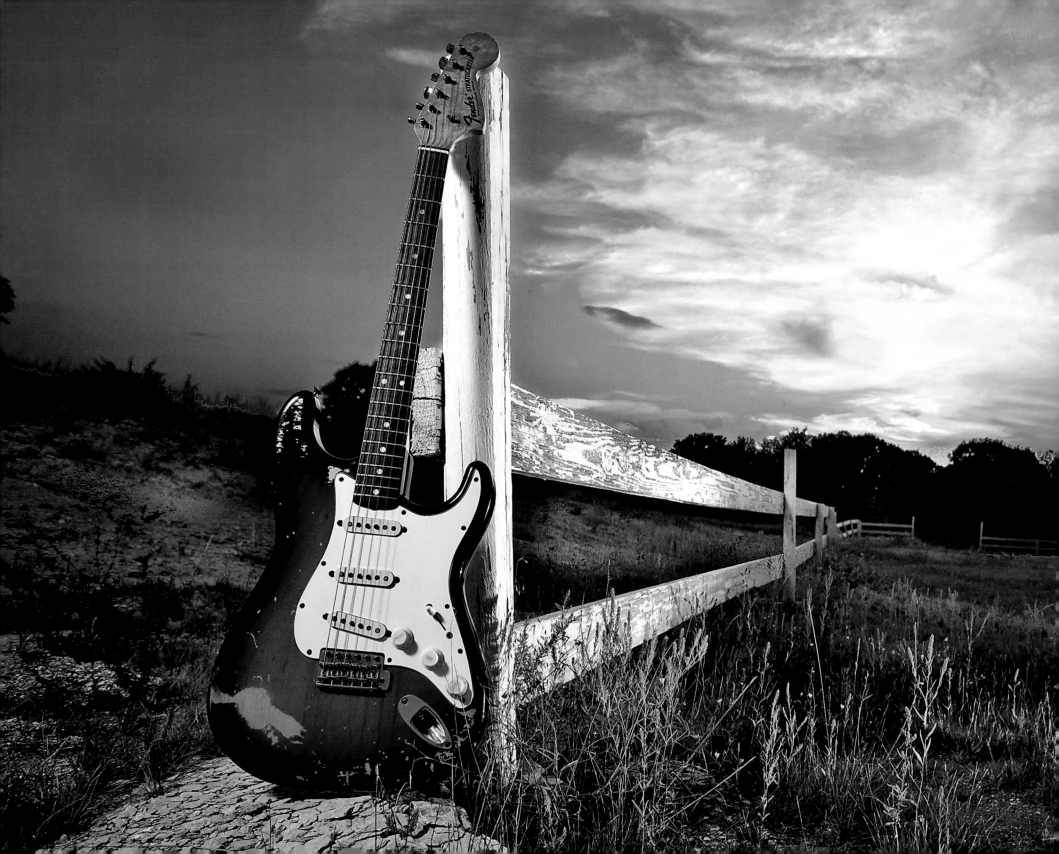

I Saved This Guitar's Life

1969 Fender Stratocaster

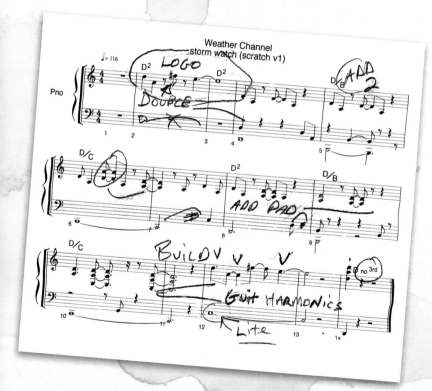

I had always wanted a Fender Strat but never could afford one. The '69 Strat was especially iconic, because that was the year Fender changed to a larger headstock and a U-shaped maple neck. In late July 2005, about a month before Hurricane Katrina, I was in New Orleans for some sessions for WWL-TV and found this Strat at a vintage music store.

Two things are special to me about this Fender: I probably saved that guitar's life, because the music store was destroyed a month later during Katrina, and I used the guitar to play all of the sonic logo harmonics on The Weather Channel's Storm Alert, which I believe was actually written right after Katrina (ironically enough), and is still used for all the Weather Channel's storm warnings.

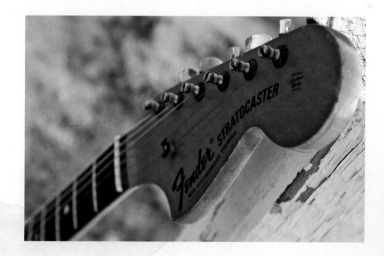

A private ranch just north of Dallas, Texas
Newspaper coverage from Hurricane Katrina
The original score for The Weather Channel's Storm Alert

13

James Taylor's Back Scratches

2002 Handmade Olson SJ

James Olson has been making his own brilliant acoustic flattop guitars in Minnesota since the late 1970s. This is number five of ten in a limited edition signed jointly by James Taylor and Olson himself. Jim Olson told me that James Taylor actually played two or three concerts with this exact guitar and he was concerned because it had belt-buckle scratches on the back. As a lifelong JT fan, I said rather innocently, "Oh, just leave the scratches on the back, Jim. OK? Please?"

The Maroon Bells in Aspen, Colorado—the most photographed peaks in North America

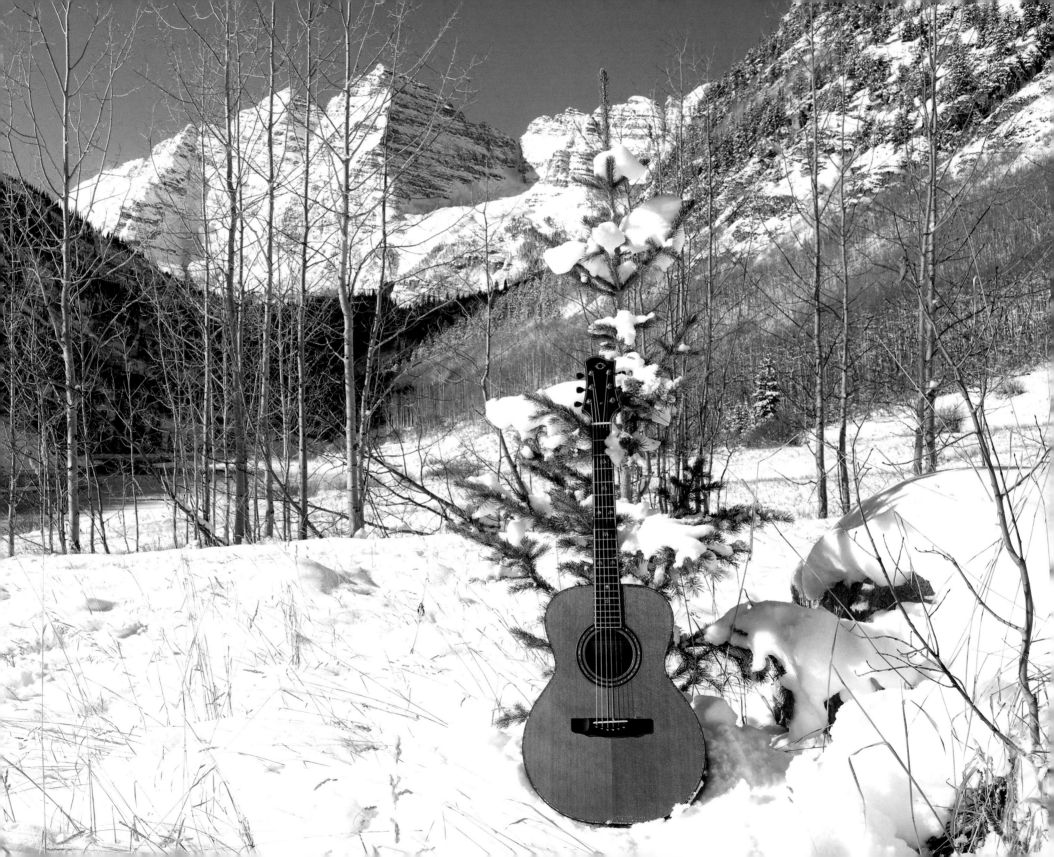

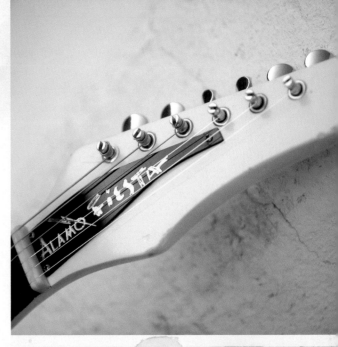

Remember the Alamo
1964 Alamo Fiesta

For musicians, there is nothing quite like your first band. Mine was The Rivals in the sixth grade. I had already outgrown a Sears Silvertone when my Dad took me to McCord's music store in Dallas, where we bought this 1964 Alamo Fiesta. The first tune I played on it was a coffeehouse standard turned bubbling rocker by The Animals called "House of the Rising Sun." The basic single pickup didn't give a lot of variety, but it was perfect for cranking out radio hits by The Kinks, Yardbirds, and of course, the Beatles.

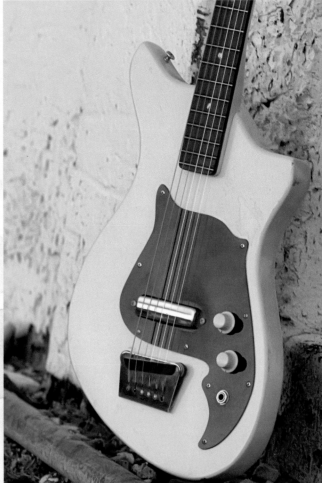

The Alamo in San Antonio, Texas

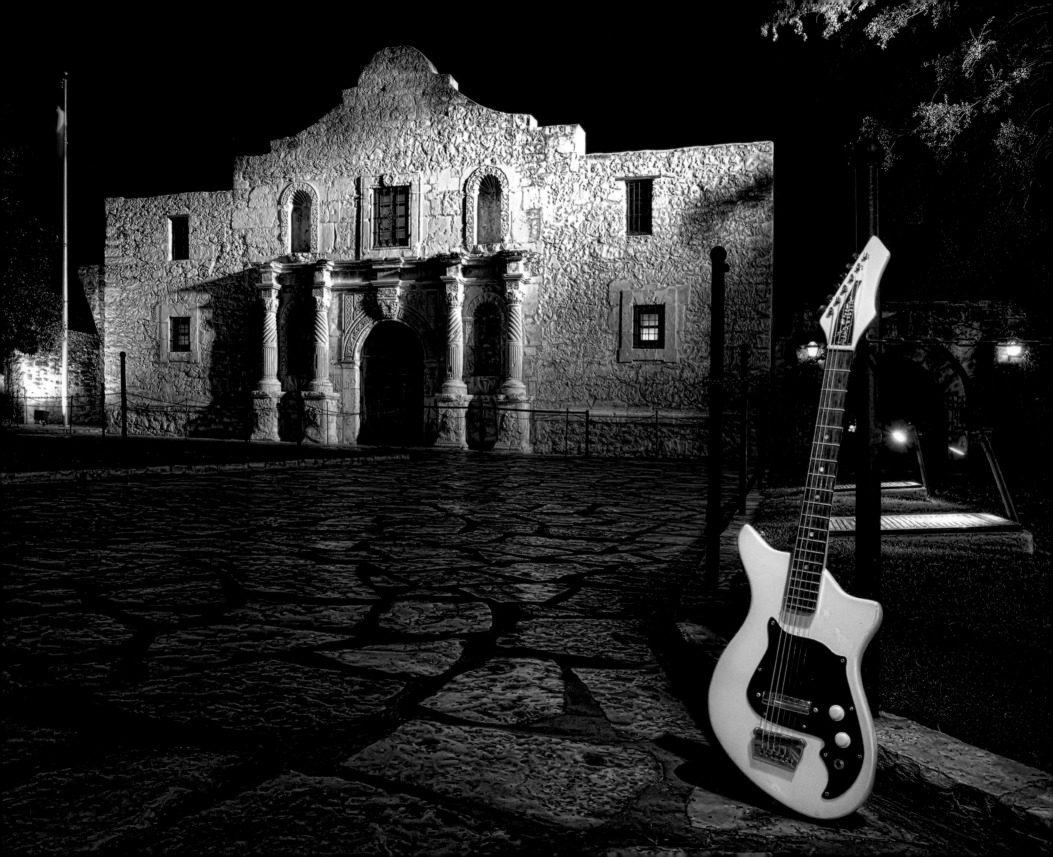

Little Daddy

1964 Gibson B-25

When I was sixteen years old I bought my first decent acoustic guitar (so long, Sears Silvertone), a used 1964 Gibson B25. It was the late sixties and right about the time that CS&N, Jessie Colin Young, and James Taylor burst on the scene. They were all major influences on me. I really got into different tunings and finger picking with this guitar, and I still write that way all the time.

The Music Room at Stephen Arnold's Santa Fe, New Mexico, home

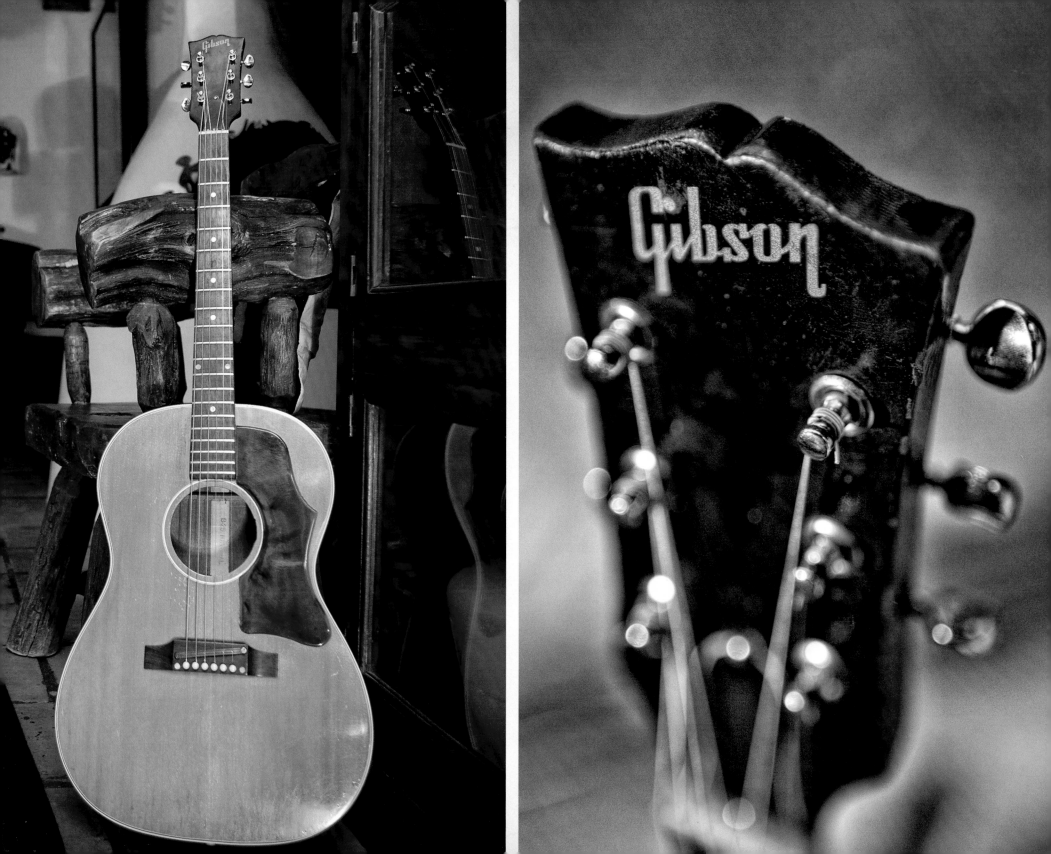

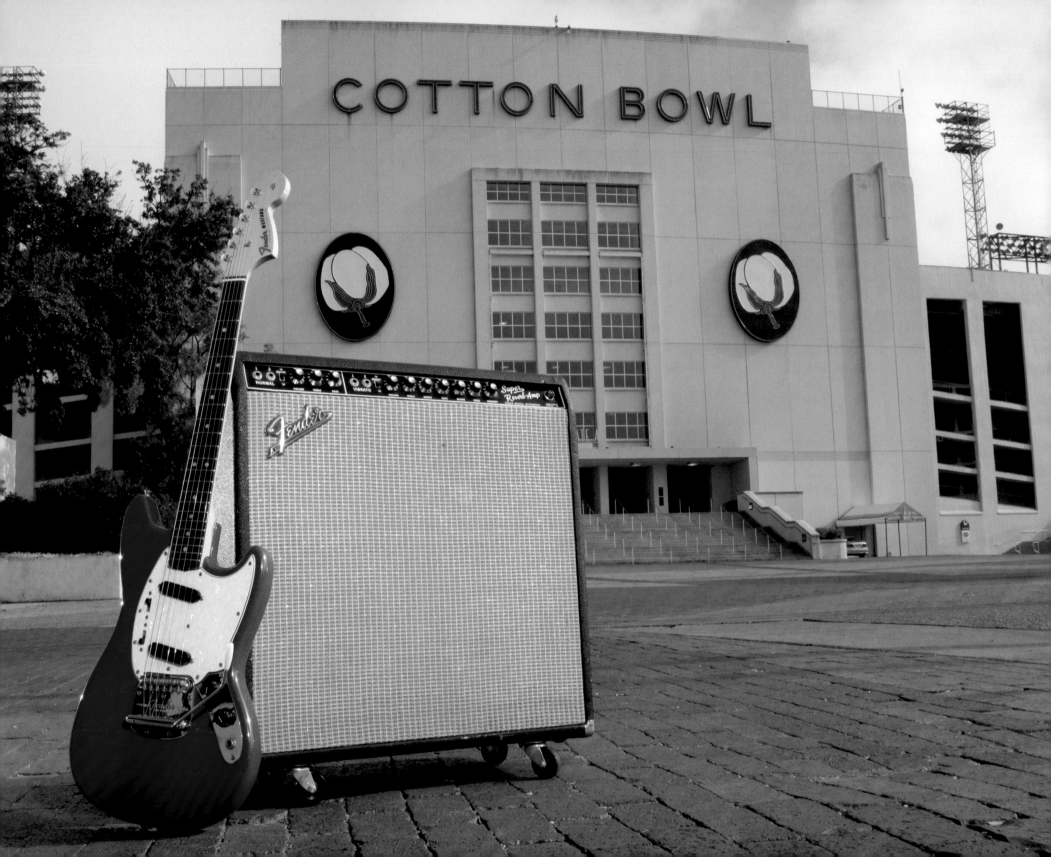

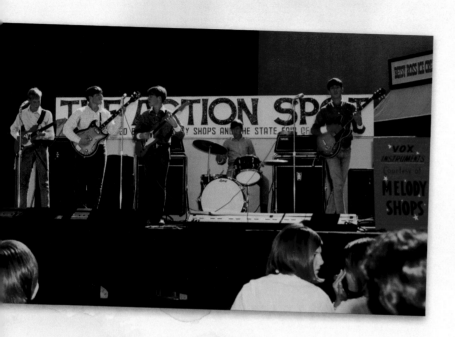

Onstage at America's Biggest State Fair

1966 Fender Mustang and 1966 Fender Super Reverb

These were my introduction to Fender products: a 1966 Mustang and a Super Reverb tube amplifier. I got them for Christmas in 1965 when I was thirteen. This guitar was a turning point. It was the first time I had owned a first-rate instrument, so I never put it down. The following year my eighth grade band, The Rivals, played on the main stage at the 1966 State Fair of Texas, known as the "Action Spot." This guitar and amp were along for the ride.

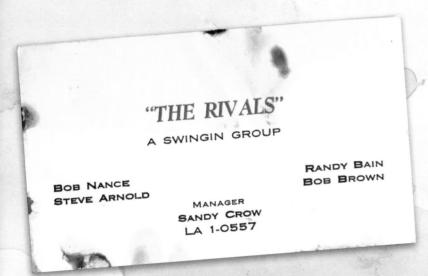

"THE RIVALS"

A SWINGIN GROUP

BOB NANCE
STEVE ARNOLD

MANAGER
SANDY CROW
LA 1-0557

RANDY BAIN
BOB BROWN

The Cotton Bowl Stadium at the State Fair of Texas in Dallas
Photo of Stephen's first band, The Rivals, as they took the stage
at the 1966 fair (Stephen is pictured on the far left)
The band's original business card

Louie the 54th

1854 Schmidt and Maul

Playing a handmade Martin built before the Civil War is a religious experience for me. Louis Schmidt was the C. F. Martin Guitar company's first luthier (that's French for "one who makes or repairs stringed instruments") and built almost all of their first guitars. In 1839 he partnered with George Maul to form Schmidt and Maul and they went on to build some prize-winning instruments of their own. When I saw this 1854 Schmidt and Maul at a guitar show, I just had to get my hands on it. Two years after he made this guitar, Schmidt rather mysteriously disappeared—thankfully not before he signed and dated it inside.

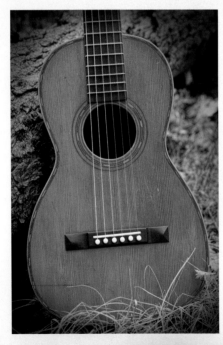

Santa Fe National Forest in north central New Mexico

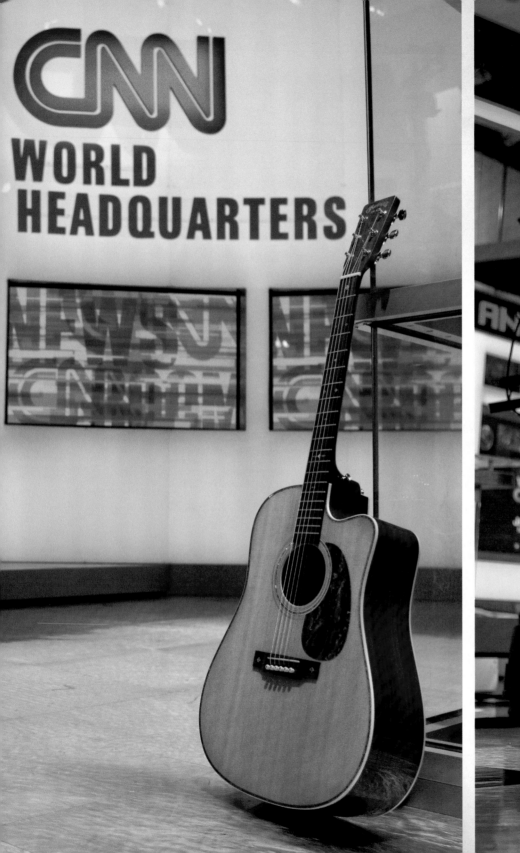

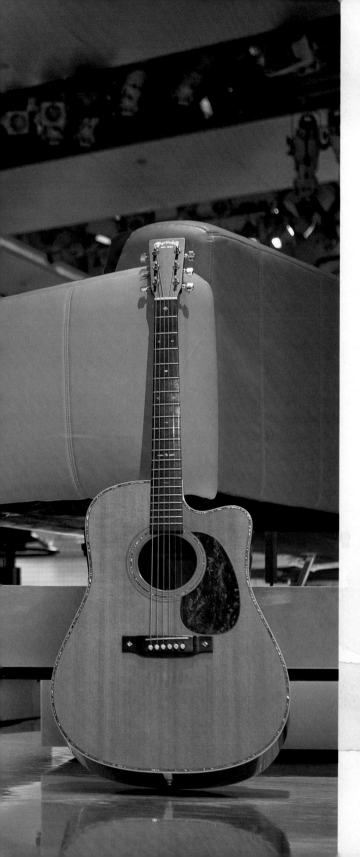

"This is CNN."

2001 Custom Martin Cut-Away (#58/100)

This guitar was in the limelight throughout my early years working with the producers at CNN. For some reason the people at *CNN Headline News* always gravitated towards the more rhythmic, acoustic material for their themes. For the rough demos we created—"scratch tracks"—the inspiration almost always came from hearing the guitar live in the room. This particular Martin will always have special meaning to me because much of the music we created for the rebranding of *CNN Headline News* launched on August 11, 2001. Like many television viewers, I was also watching, one month later, and witnessed the drama of 9/11 unfold on the air—framed by the music I had created.

Inside CNN's Studio 7 in Atlanta, Georgia

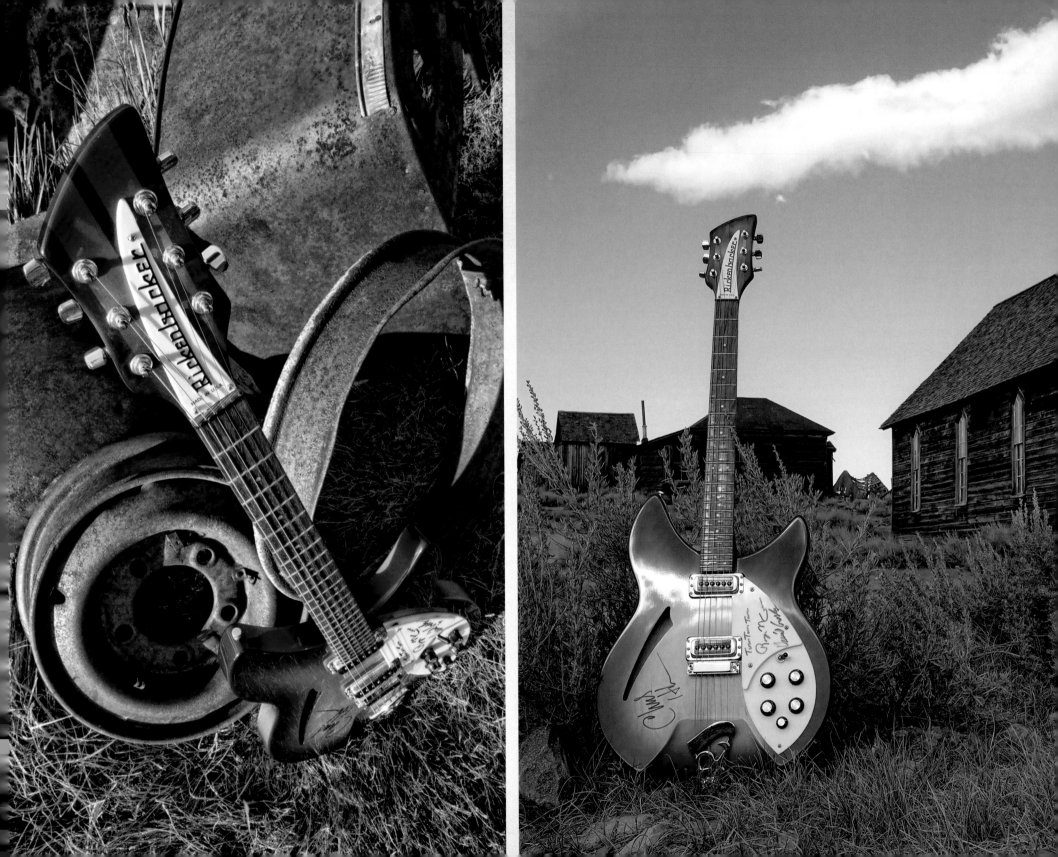

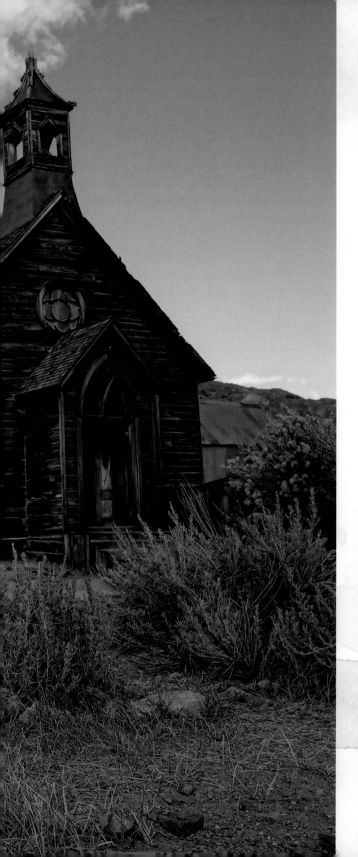

Turn! Turn! Turn!

1995 Rickenbacker 330

Most of the early groups I played in featured lots of guitars and heavy three-part harmonies, which was an early trademark of the Byrds. David Crosby, Chris Hillman, and Roger McGuinn, a trio of original members, all have a slice of their musical DNA wrapped up in the jingle-jangle sound of a Rickenbacker. Each guy also took the time to autograph this guitar, making it even more special. McGuinn's *pièce de résistance* included the band's most popular song, "Turn! Turn! Turn!" next to his signature at the top of the pick guard. As the story goes, legendary songwriter Pete Seeger pulled the lyrics from the first eight verses from Ecclesiastes 3. Rickenbacker was the first company to produce electric guitars. This 330 has an exceptional sound with two single coil pickups on a full size body, accented by a traditionally shaped sound hole.

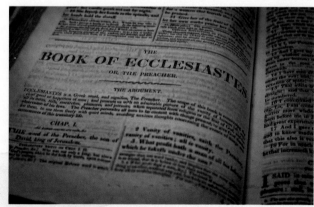

Historic gold-mining ghost town in Bodie State Historic Park in Bodie, California
Early nineteenth century Bible open to the book of Ecclesiastes, which inspired "Turn! Turn! Turn!"

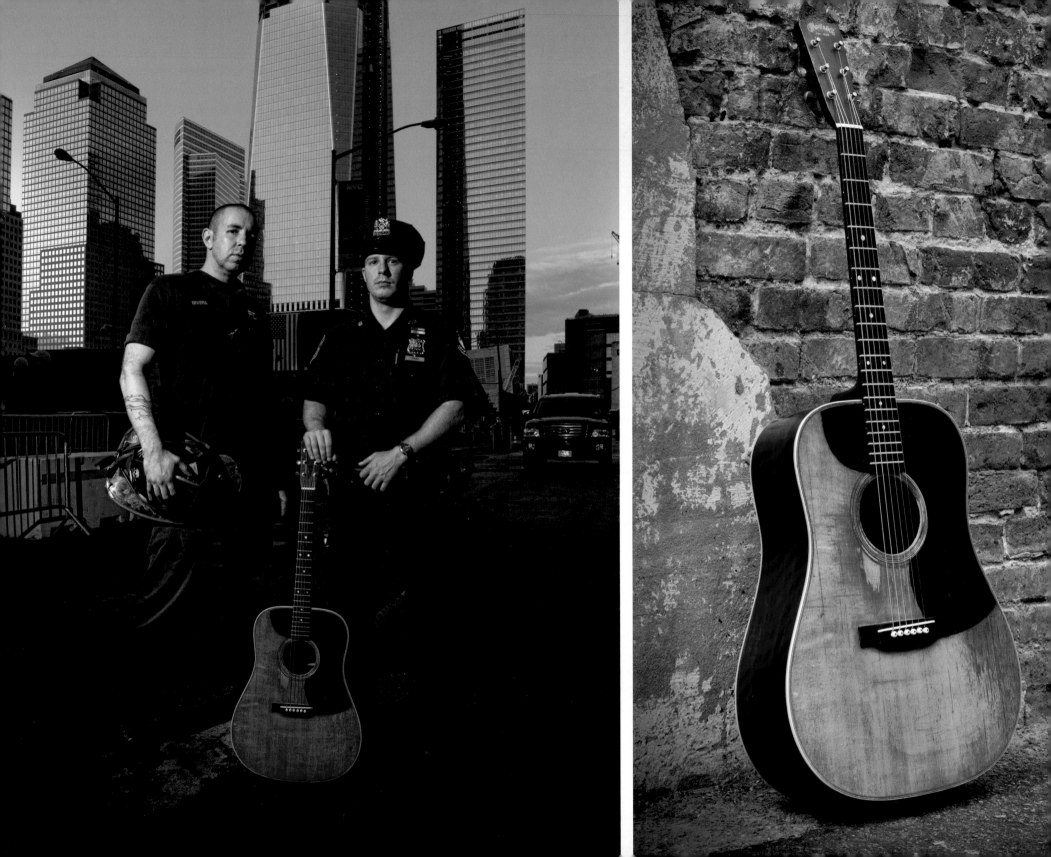

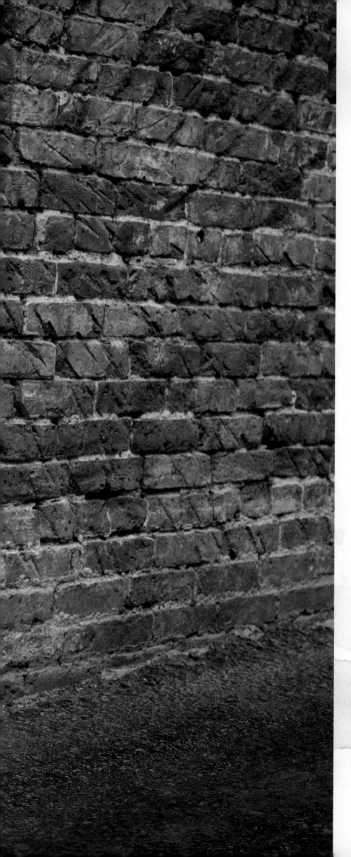

Ground Zero: Ten Years Later

1950 Martin D-28

Having the rare opportunity to create signature music for a compelling series of CNN reports called "Ten Years Later" was a privilege and, at the same time, a rather intimidating task. The complex range of emotions surrounding 9/11 transcends words. However, music has the unique ability to heal and to draw people closer together. This composition required just such a posture, and this beautiful guitar set the tone perfectly. It is a stunning instrument with its Brazilian Rosewood back and sides, and it features the original custom pick guard.

A New York firefighter and a member of the NYPD photographed together just outside the 9/11 Memorial Museum in New York, New York

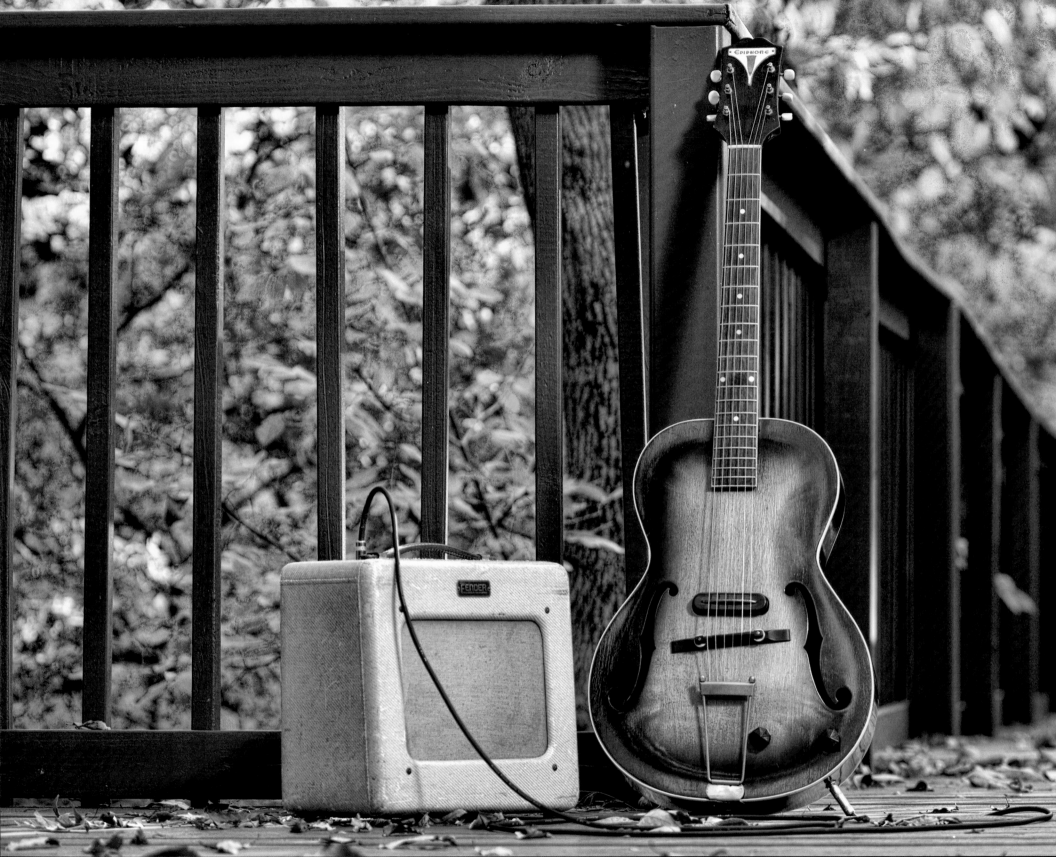

Retro Mania

1941 Epiphone Century and 1951 Fender "Tube" Champ Amp

You would be flabbergasted by how many clients want to go "lo-fi," looking for the sound of fat strings on an old hollow body with f-holes and a simple wooden bridge, "chuck, chuck, chuckin'" away. We have even had requests to add sound effects of vintage record scratches to the final mix. T-Bone Walker and Charlie Christian would have loved it. For my money, it doesn't get much more retro than the classic combination of a 1941 Epiphone Century and the 1951 Fender Champ tube amplifier that I affectionately refer to as my "Sittin' On the Dock of the Bay" set-up.

On the back deck of the Stephen Arnold Music Studio in Dallas, Texas

Mondays at the Troubadour

1970 Guild D-40

Mondays were open mic night at the Troubadour in West Hollywood. Artists submitted tapes in advance to be selected as one of the five or six acts to perform. After weeks of dropping off cassette demos, I got this strange phone call late one Monday afternoon. "You wanna play—tonight?" asked the voice on the other end of the phone (obviously someone had canceled at the last minute). To step onto the same stage where Bob Dylan, James Taylor, Buffalo Springfield, Joni Mitchell, and others made their debut was awesome. Could some of their cosmic energy rub off on my band, Poor People? Not so much. We were the last band on the schedule, and since the others ran long we only got to play a couple of songs.

Outside the legendary Troubadour club in West Hollywood, California

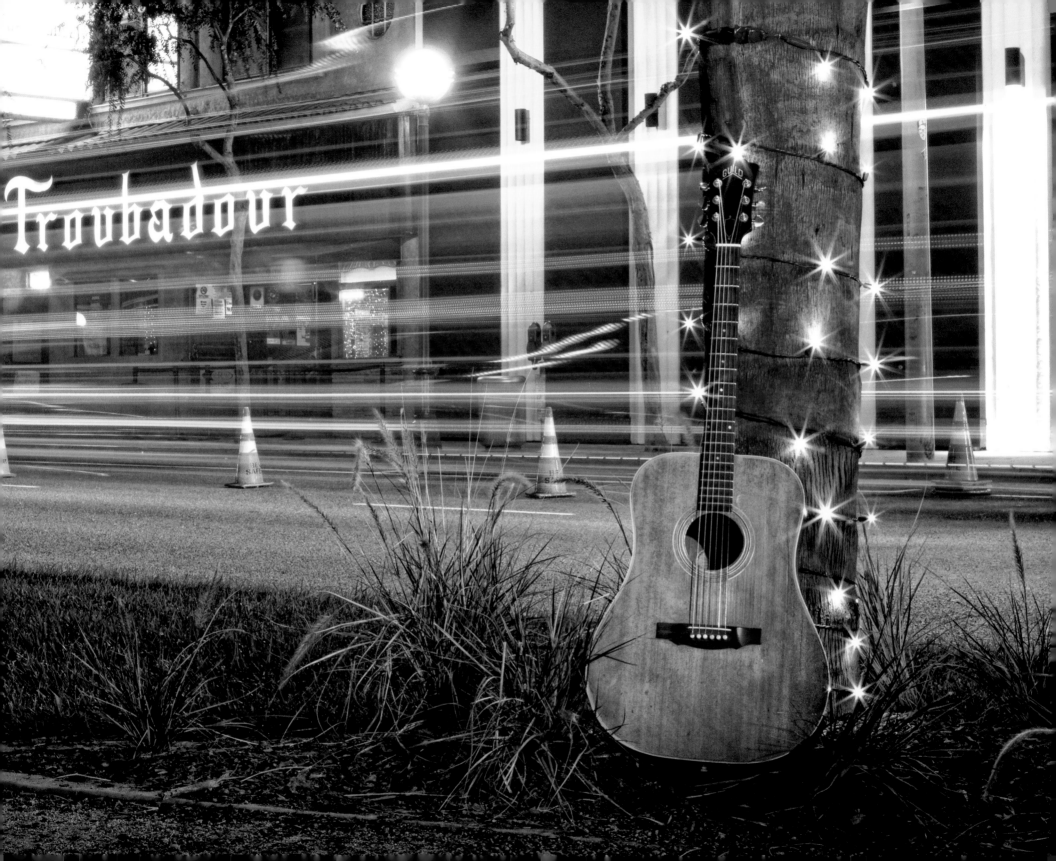

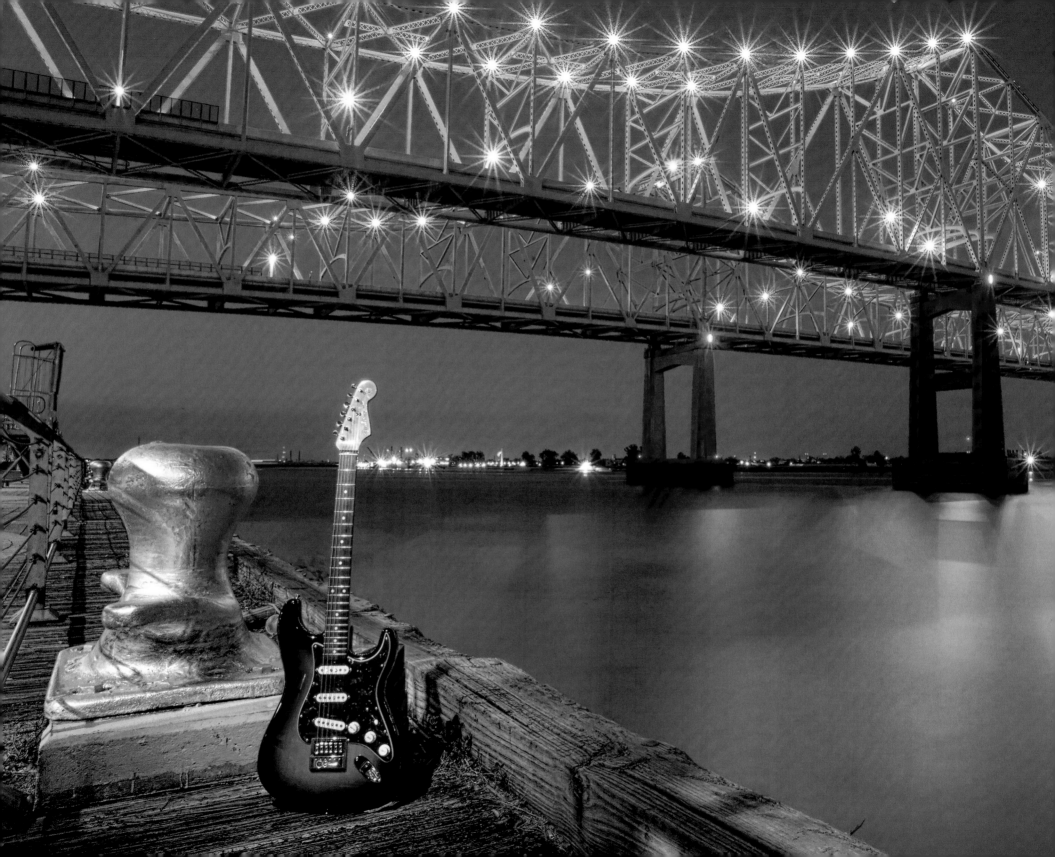

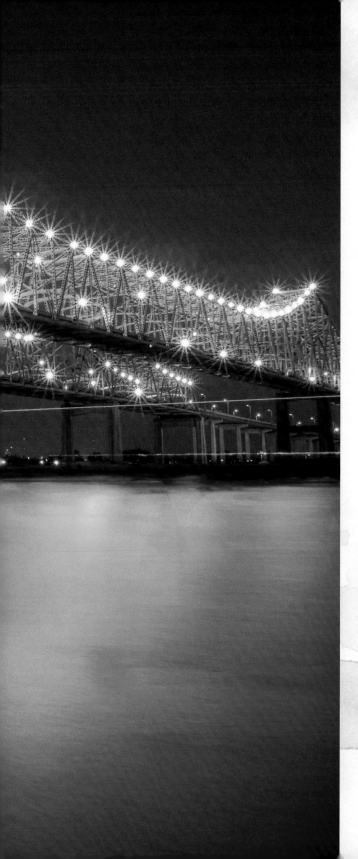

God Bless Louisiana

2007 John Mayer Signature Stratocaster

While creating a piece for WGNO-TV in New Orleans, the station's creative director thought the music should have the "soulful intensity of an altar call at a Bayou tent revival," driven by "a sweaty preacher in the swamp." He suggested I listen to a specific voice-over before writing a note, then pick up my guitar and "see what happens." I listened carefully and realized the voice-over was the melody. All I had to do was strap on my Fender and develop the chords. The project ended up winning a PROMAX Gold Medallion for best original music. There's an old saying that the client may not always be right, but they will always be the client. In this case, he was right.

Along the banks of the Mississippi River, under the
Greater New Orleans Bridge in New Orleans, Louisiana

An Uncommon Cure for a Common Case of Writer's Block

1977 Takamine 12-String Acoustic

Some of my guitars have quite memorable stories attached, and the 1977 Takamine 12-string, commonly referred to as the infamous "lawsuit" guitar, is a good example. I liked this one because it looked (and sounded) exactly like a Martin guitar. Apparently C. F. Martin thought so too and eventually sued the Japanese guitar maker, forcing them to radically modify the instrument's design. Not a ton of them are still around, but I have one with a special purpose: whenever I am stuck in a creative slump, picking up this guitar always seems to take me in a whole new creative direction.

Inside an abandoned farmhouse in McKinney, Texas, that is no longer standing

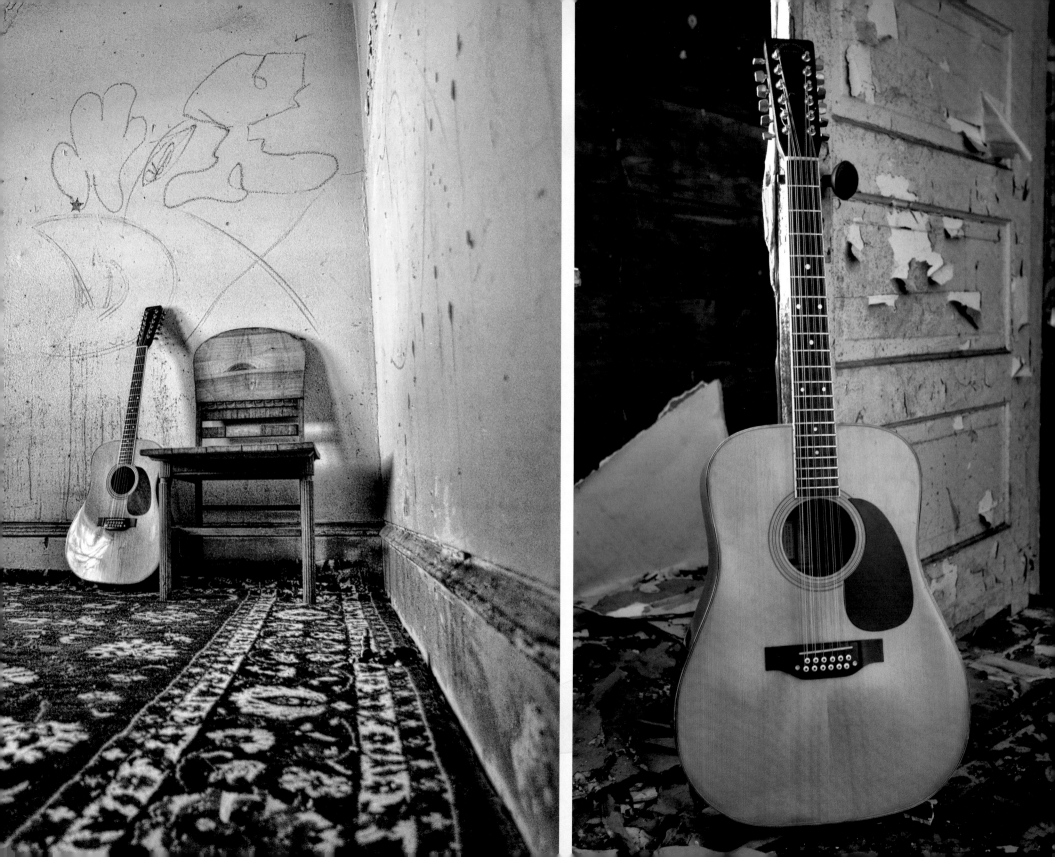

Daddy's Girl
1970 Guild D-40

Pictured here in our Santa Fe studio, this 1970 Guild D40 has always been my main guitar. It's my first "dreadnought" (the deep body style originated by C. F. Martin) full-size that I got when I was seventeen. This Guild has been everywhere: senior talent show, college bands, gigs from Los Angeles to Seattle to Scottsbluff, New England, Singapore, Paris, Rome, and even Jerusalem. I used her to write my very first jingle for The Hungry Ear at Valley View Mall in Dallas (their check bounced), my first tracks for CNN, and on my first recording session. Today she is always close, at the ready for the next deadline.

Stephen Arnold Music Studio, just outside of Santa Fe, New Mexico

Django

1936 Gretsch Model 30 Archtop

I originally got this as a "wall hanger" just because I loved those distinctive f-holes. But after a little work it played as beautifully as it looked. Gibson actually made the first archtops; however, Gretsch took them in a much different direction. This one has a perfect neck angle and that vintage Django Reinhardt tone. There's nothing like the sound of some Latin Gypsy swing on an old archtop.

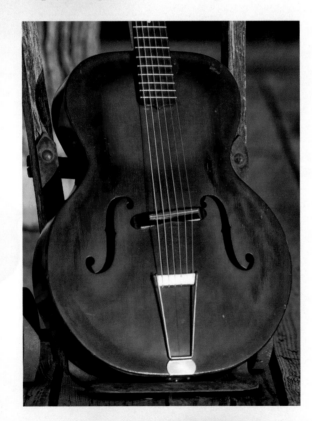

Bourbon Street's iconic street performer, "The Wizard of Bourbon Street," late one Sunday night in New Orleans, Louisiana

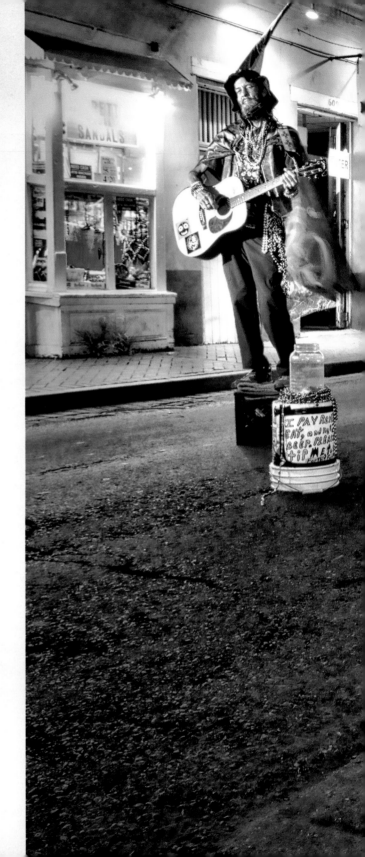

40

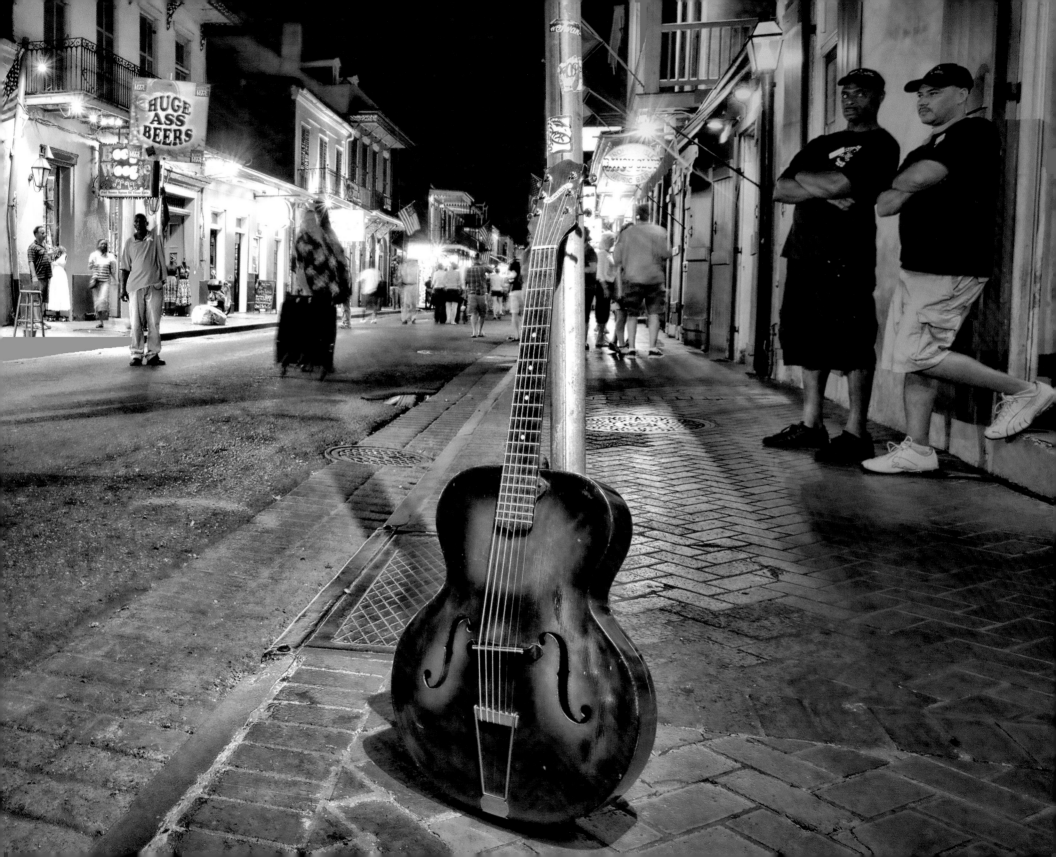

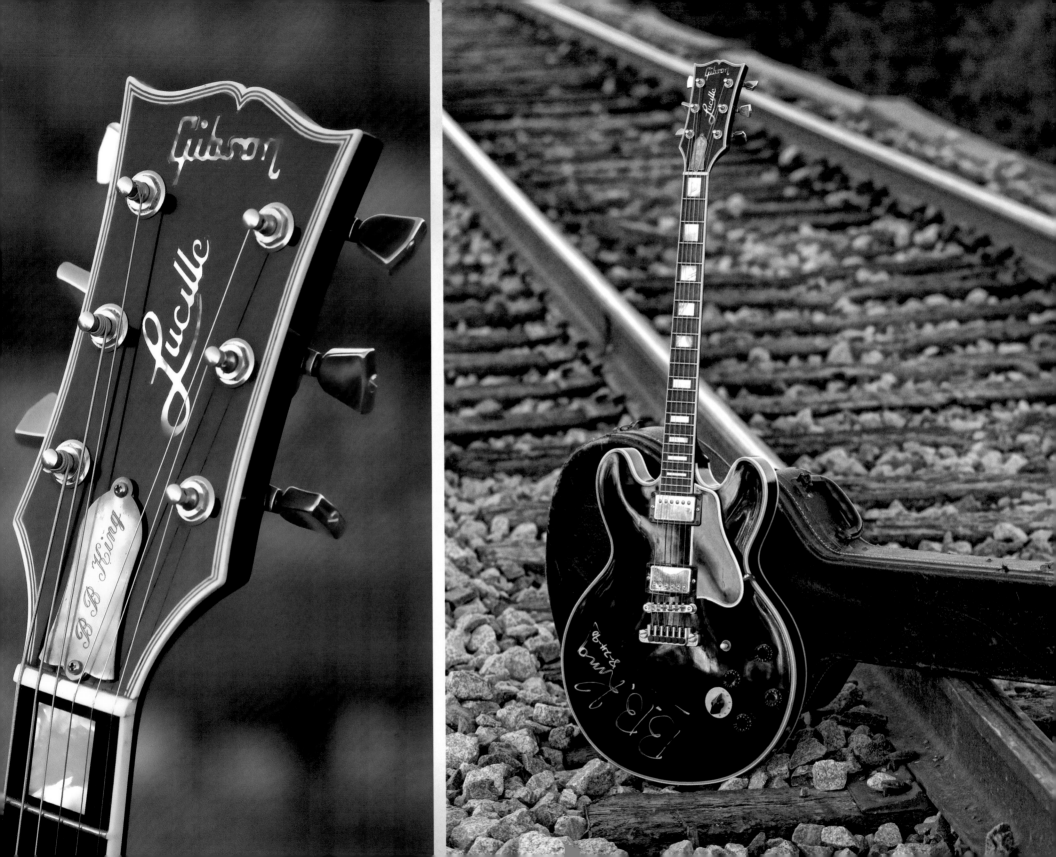

Blues Power

1990 Gibson ES-355 B.B. King Lucille

Like so many guys my age, I cut my blues chops listening to B. B. King records and ripping off as many of his licks as I could. So a few years ago when a replica of "Lucille," the legendary black-as-coal Gibson ES-355 with gold hardware, showed up at a Texas "Make-A-Wish" charity auction, I jumped all over it. Unfortunately I discovered something else in the process: owning a guitar named Lucille does not necessarily mean you can play the blues.

A set of railroad tracks leading into Memphis, Tennesseee

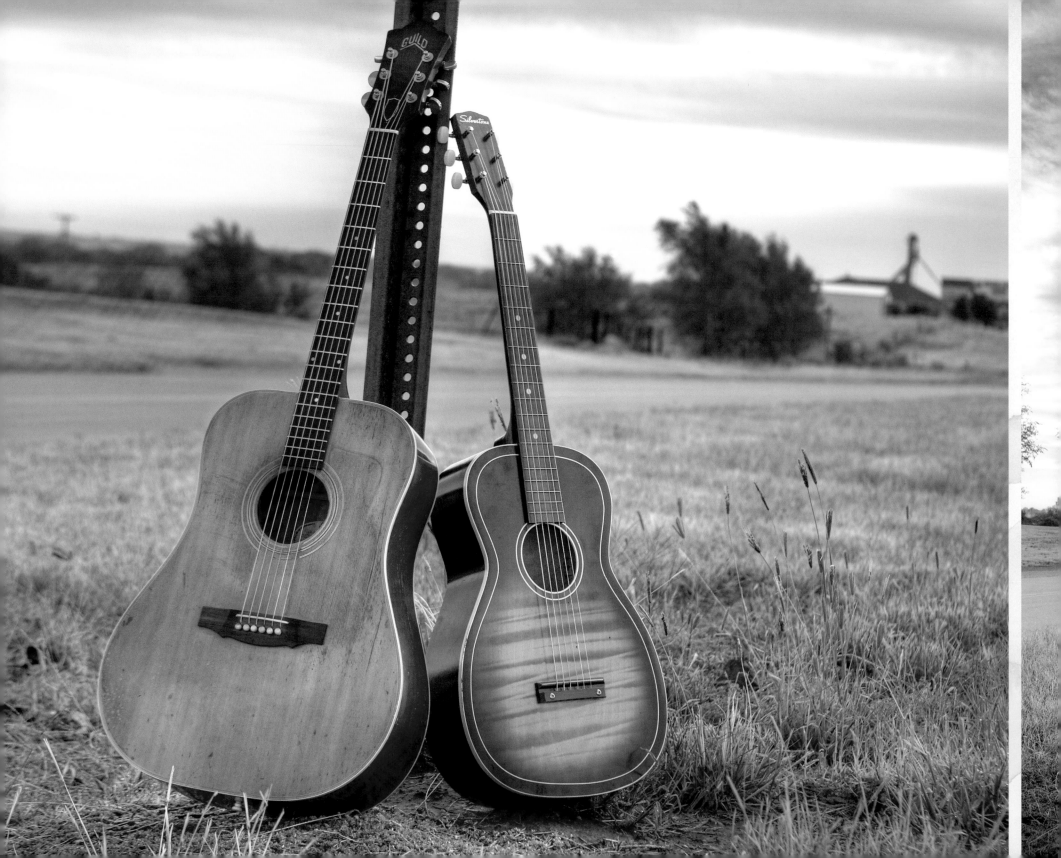

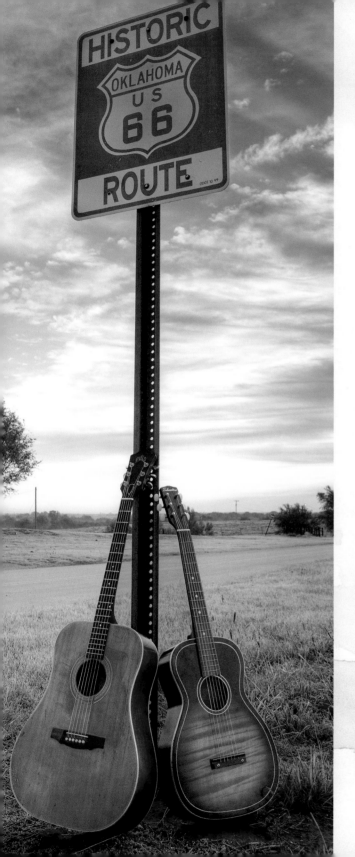

Seven to Seventeen

1970 Guild D-40 and 1959 Sears Silvertone Acoustic

One of my favorite images is of my first guitar, a Sears Silvertone that my mom gave me when I was seven, next to my "battle scarred" Guild D-40, which I got ten years later. The Guild was my first "serious" acoustic guitar, and even though it may look like it has been to hell and around the corner (trust me, it has), it still plays beautifully.

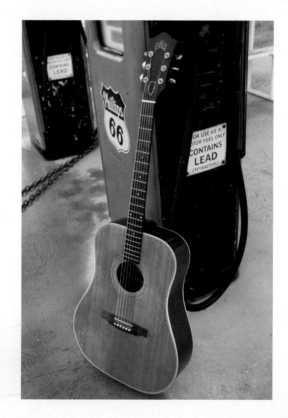

Along historic Route 66, running through central Oklahoma

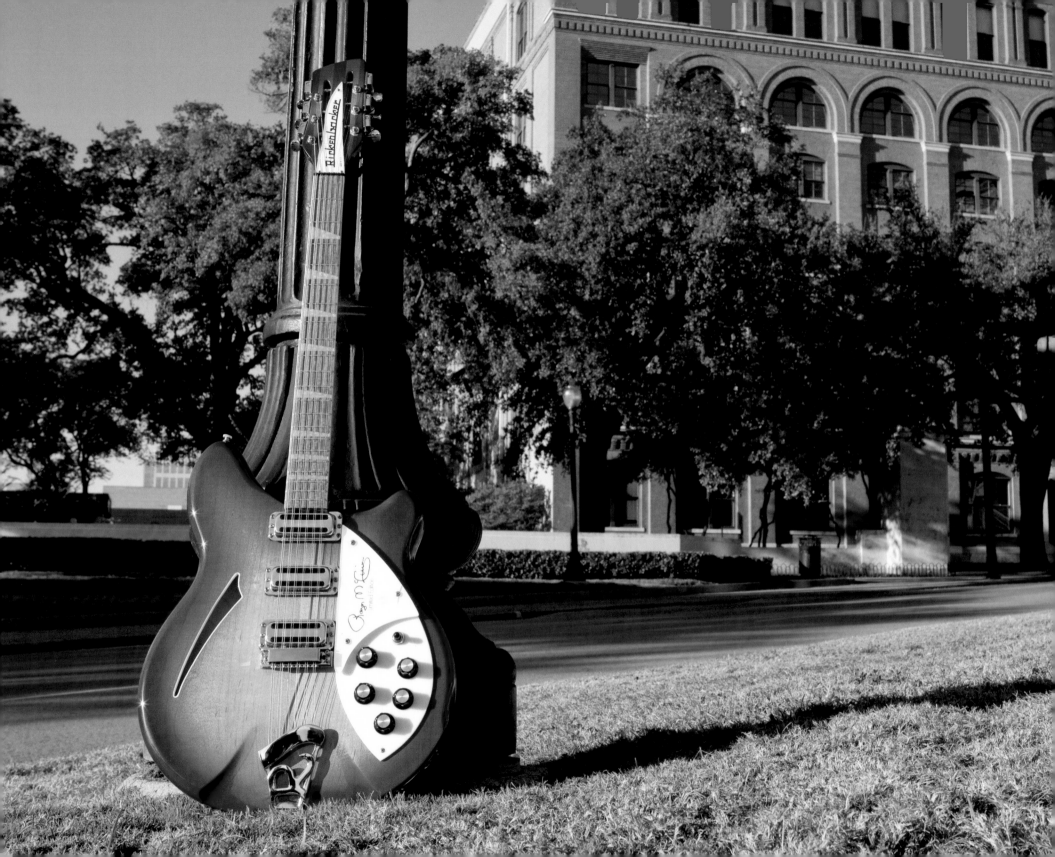

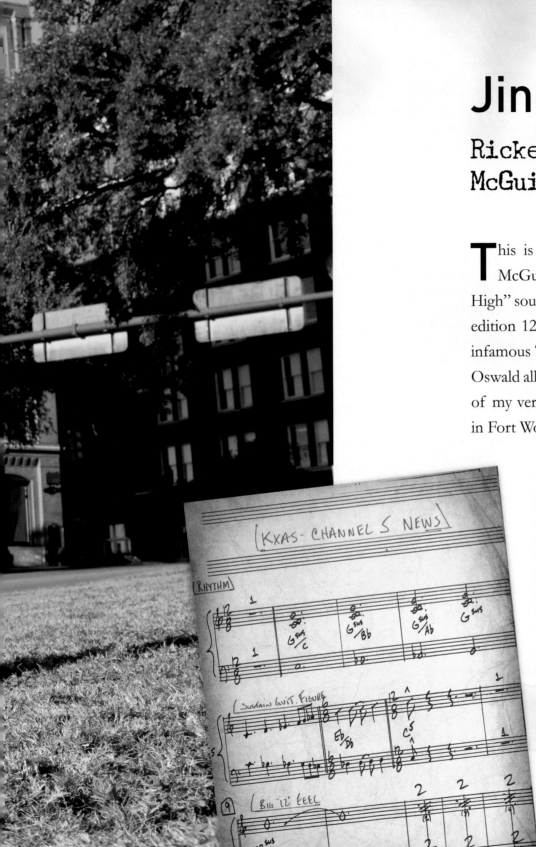

Jingle-Jangle
Rickenbacker 370/12 Roger McGuinn Signed-Edition 12-String

This is a reissue of the 1960s Rickenbacker 370/12 that Roger McGuinn used to create the celebrated jingly-jangly "Eight Miles High" sounds for the Byrds. He autographed this one, which is a limited edition 12-string (152 out of 1,000 made). This image combines the infamous Texas School Book Depository in Dallas, where Lee Harvey Oswald allegedly shot President John F. Kennedy in 1963, and the score of my very first broadcast news package for KXAS, the NBC station in Fort Worth.

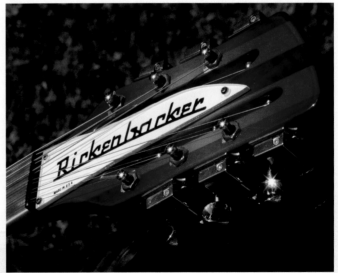

The former Texas School Book Depository, now the Sixth Floor Museum, in Dallas, Texas
The original score for KXAS—Channel 5 News

Meet the Fifth Beatle

1959 Gibson Jumbo J-160E

Where were you the very first time you heard the Beatles? The Fab Four were a huge influence on me, and the first Beatles song I recall hearing was "Love Me Do." Later I learned that they recorded that song with a Gibson J-160E, which is one of the first acoustic-electric models Gibson ever produced. I can still visualize a pensive John Lennon strumming it on the set of the motion picture *Help*, singing "You've Got to Hide Your Love Away" in unforgettably iconic fashion. This one I snagged from the original owner, and the original receipt (for $155) is still in the case. Sometimes I plug it into my Fender Super Reverb amp and strum those two chords—G and C—over and over and over.

On the porch of an abandoned ranch just north of Leadville, Colorado
The original receipt for the 1959 Gibson Jumbo J-160E

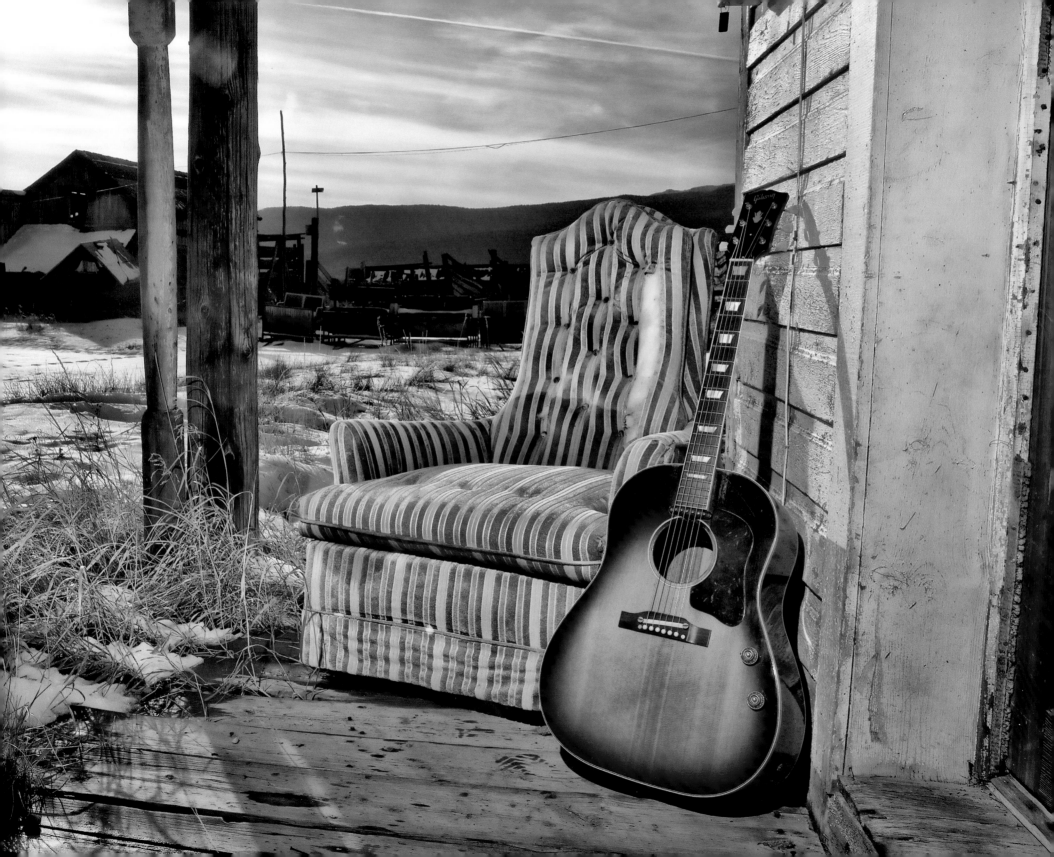

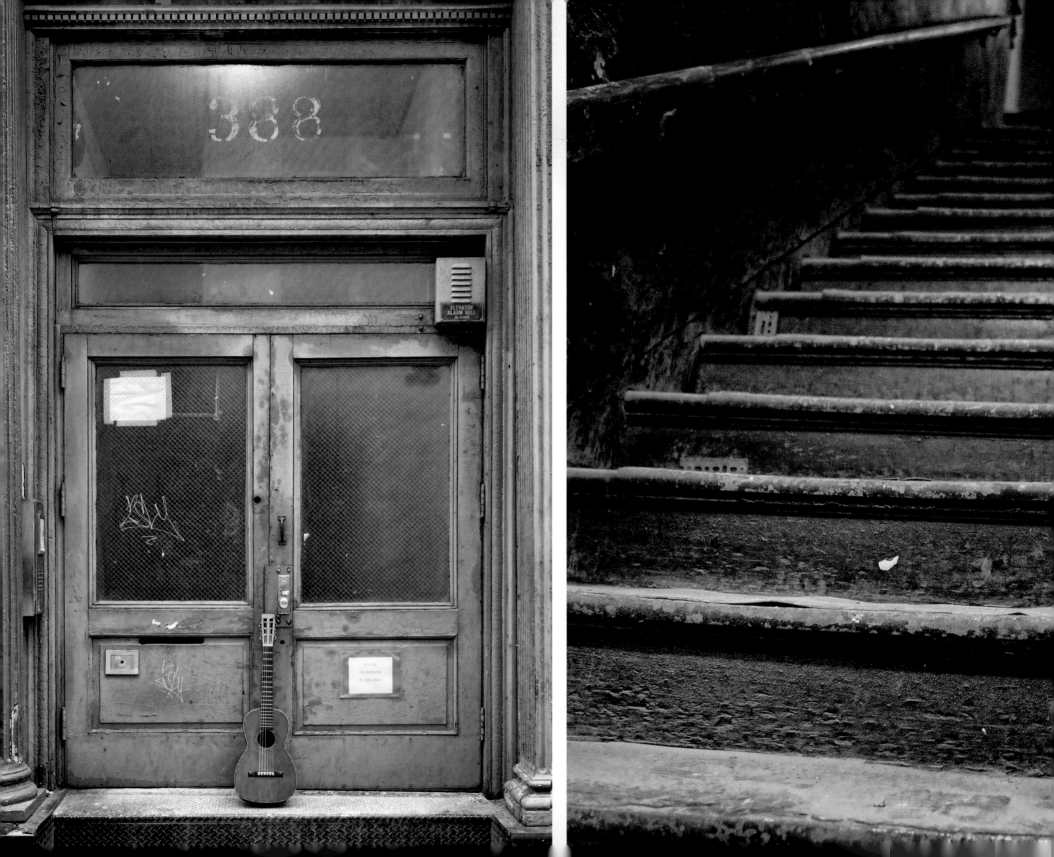

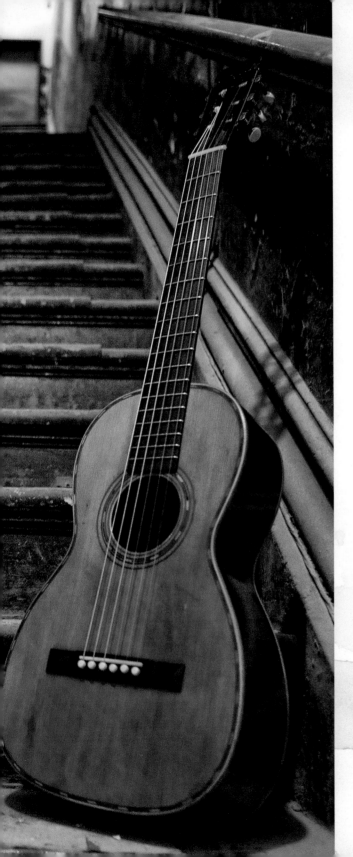

Born on Broadway

1854 Schmidt & Maul Slot Head

For many people, returning to a birthplace—much like visiting a former home—can create tremendous nostalgic introspection. C. F. Martin's original luthier was a man named Louis Schmidt. Although old and faded, Schmidt's signature—dated August 18, 1854—can still be seen inside this guitar. On closer inspection, I noticed there was also an address included: 388 Broadway, New York, New York. On a lark, we decided it was time to take this wonderful instrument back to her place of birth, reintroduce her to the neighborhood, and snap a few photographs to celebrate the occasion.

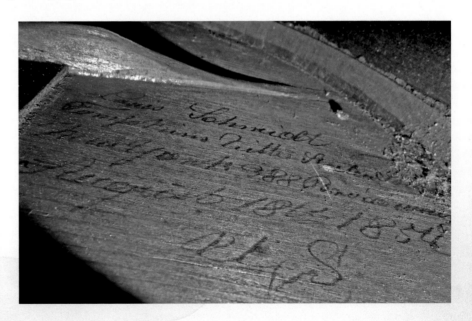

Entryway and inside stairway of 388 Broadway, New York, New York
Schmidt's signature, dated 1854, from inside the body of the guitar

51

It's Only Rock 'n' Roll

1969 Fender Telecaster Relic

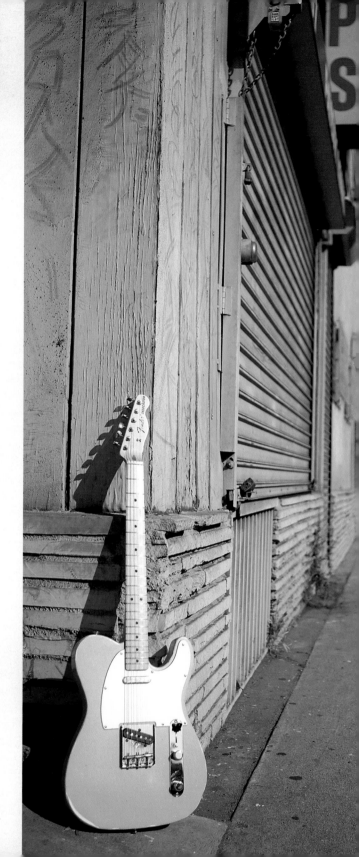

This 1969 Fender Telecaster is a relic, which means it only *looks* like a '69, but it plays and looks exactly like my original '69. It has a butter neck and that golden Tele tone. Unfortunately I had to hock my original at a pawnshop during my salad days in Los Angeles. I needed to pay the rent.

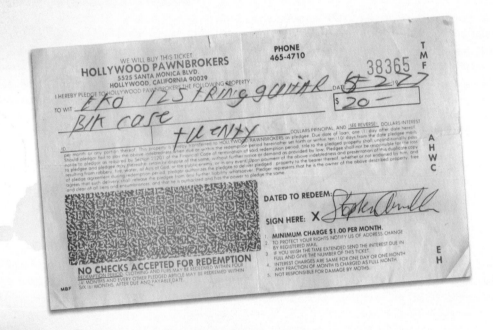

Outside a pawnshop in Los Angeles, California
One of many tickets for items pawned during Stephen's time in LA

52

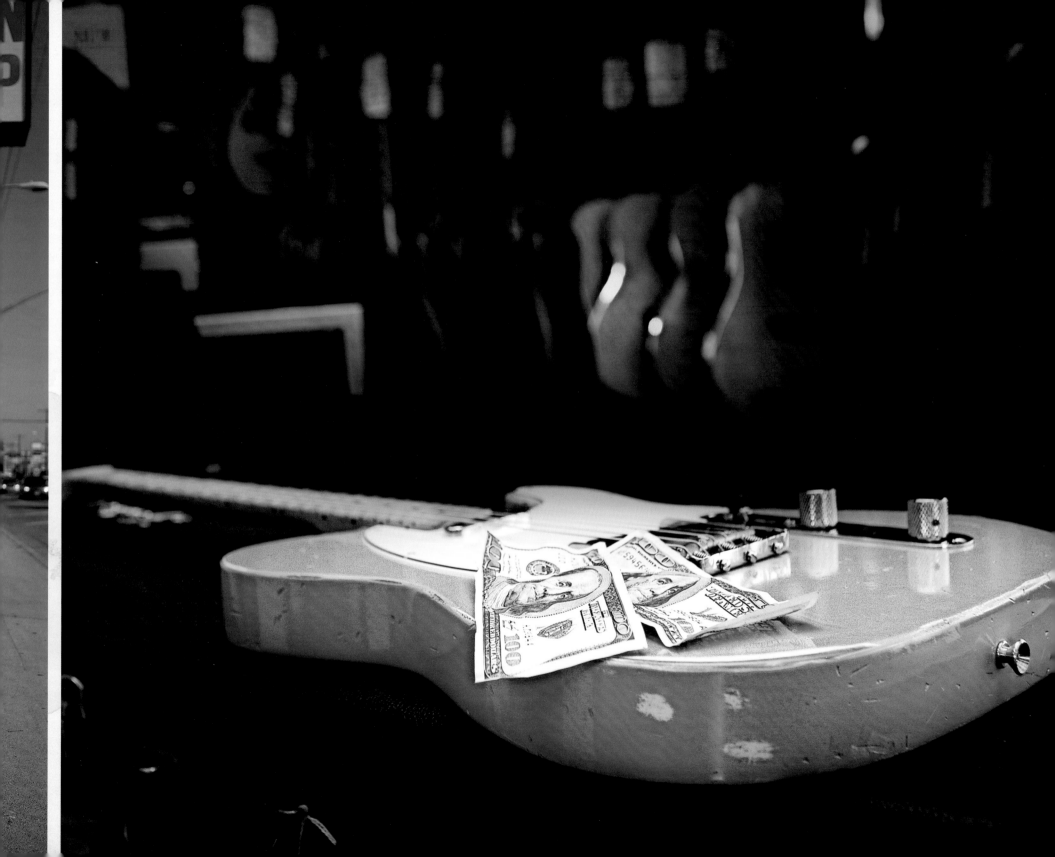

Crossroads
1929 Gibson L-1

Originally built during the Great Depression, these diminutive, lightly-constructed guitars were made famous by the legendary Robert Johnson. A dirt-poor Mississippi Delta bluesman—known for the Faustian legend connected to his midnight meeting at the infamous "crossroads"—he influenced generations of performers such as the Rolling Stones, Bob Dylan, The Allman Brothers Band, and yours truly. Johnson staged the second of his two documented recording sessions in 1937 at a ramshackle studio in the Brunswick Record Building on Park Avenue in Dallas's Deep Ellum. Several years ago, Eric Clapton retraced Johnson's footsteps, recording an album in the same spot. Deep Ellum remains an active music center to this day.

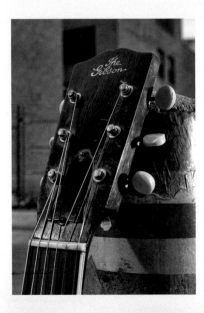

508 Park Avenue, Dallas, Texas, where legendary bluesman Robert Johnson recorded, in-studio, thirteen songs in two days—June 19 and June 20, 1937

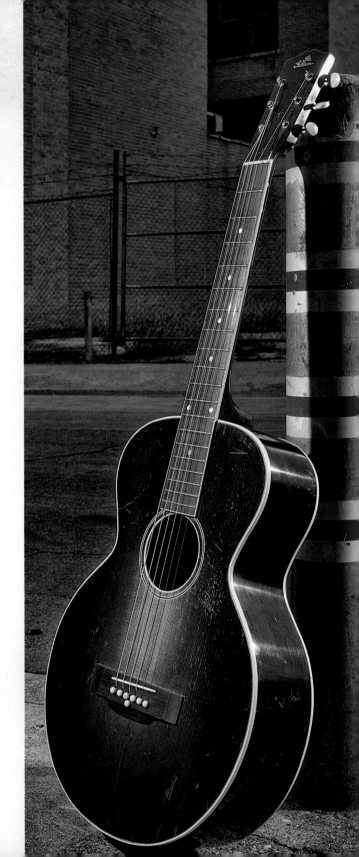

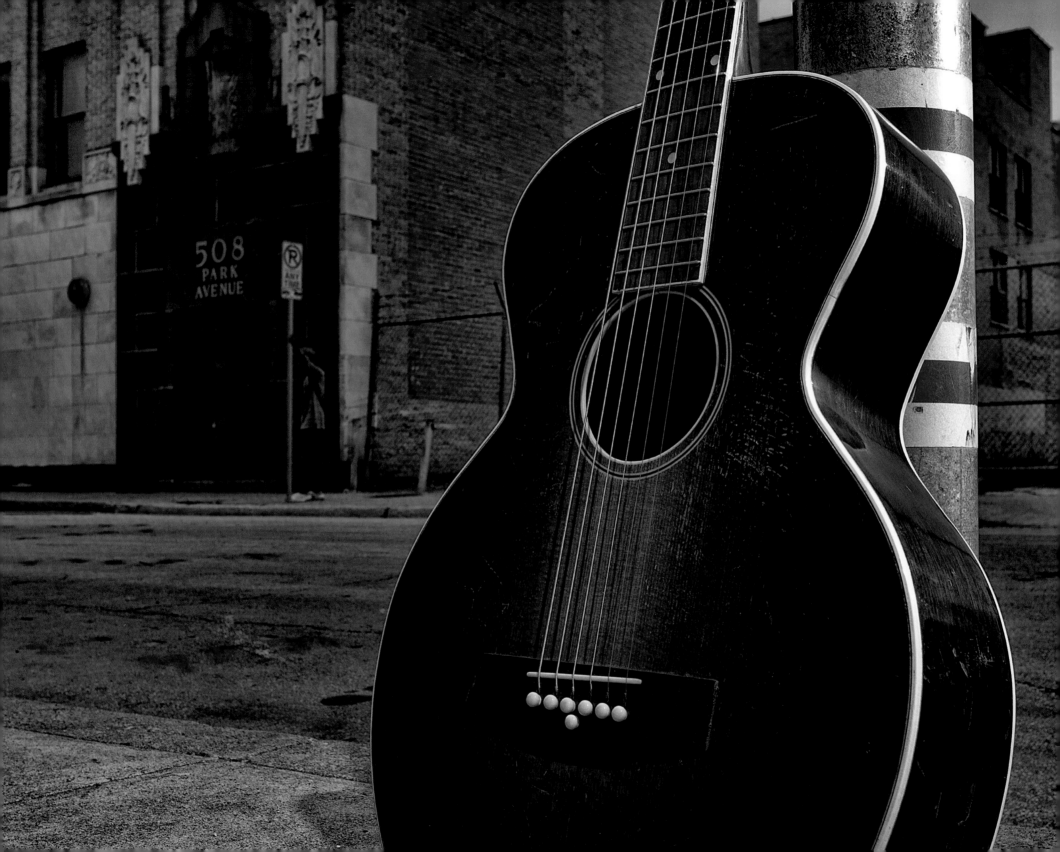

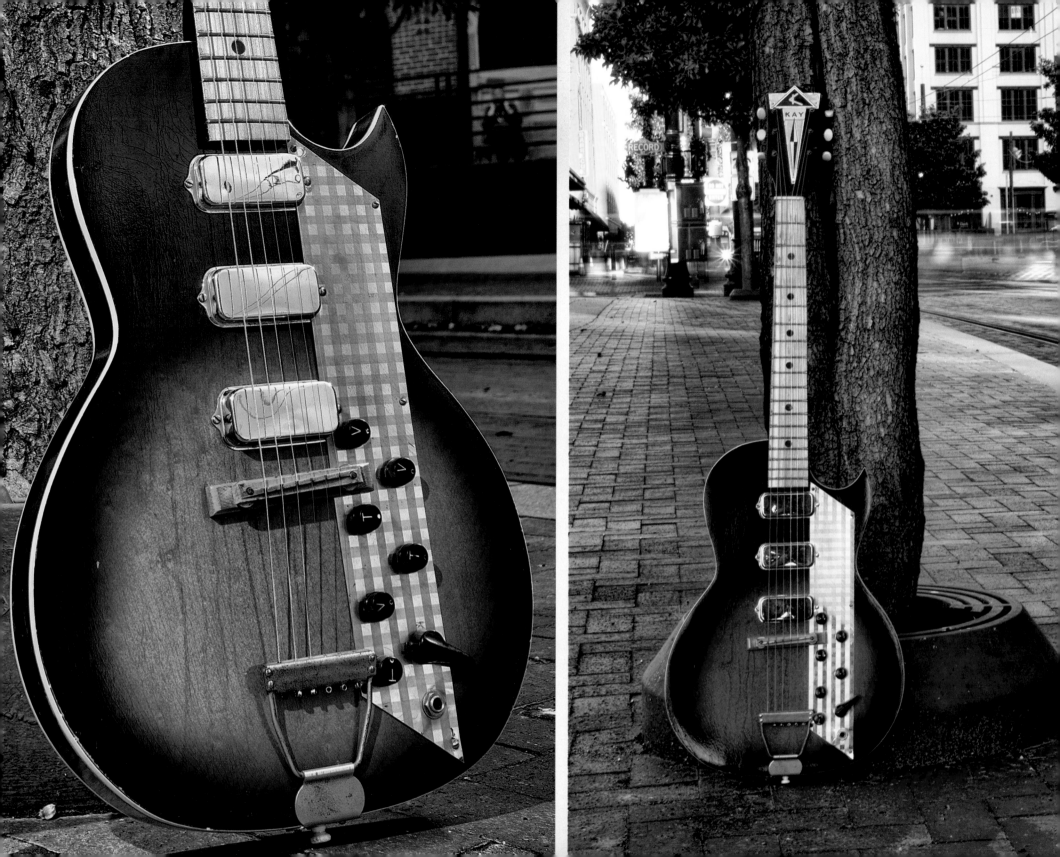

Garage Bands Rule

1963 Kay Value Leader

Pre-punk rockers with names like Question Mark and the Mysterians ("96 Tears") and the Sir Douglas Quintet ("She's About a Mover") provided a jingle-jangle soundtrack of the early and mid-1960s. The picture perfect indie band guitar is a 1963 Kay Value Leader, and it hung on my wall for years. One day I took it down, plugged it in, and rediscovered its brilliant range of tones—ideal for blues progressions and a number of Brit-pop pieces. The triple low-output pickups help overdrive my amps, and it gives me that grubby sound that even the more modern day garage rockers like Pearl Jam and REM seem to love so much.

Historic West End in downtown Dallas, Texas

Two-Headed Gothic Monster

Harp Guitar

Saint Louis Cathedral in New Orleans has the distinction of being the oldest continuously operating cathedral in the US. About the time it was completed in the late 1700s, harp guitars were coming of age. Originally referred to as "medieval fiddles," the instruments were played mostly by Mongolian monks fueled by the spirits of the day. One of my favorite players is the late Michael Hedges, a Grammy-winning guitarist known for his alternative tunings and New Age sensibilities. He played harp guitar beautifully and was such an inspiration. It is a complicated instrument with intricate tunings. But I am a huge fan and an ardent admirer of the extraordinary sound.

The Saint Louis Cathedral in downtown New Orleans, Louisiana

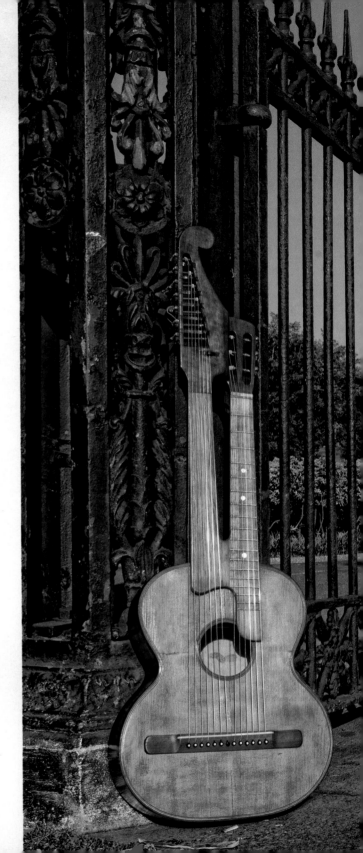

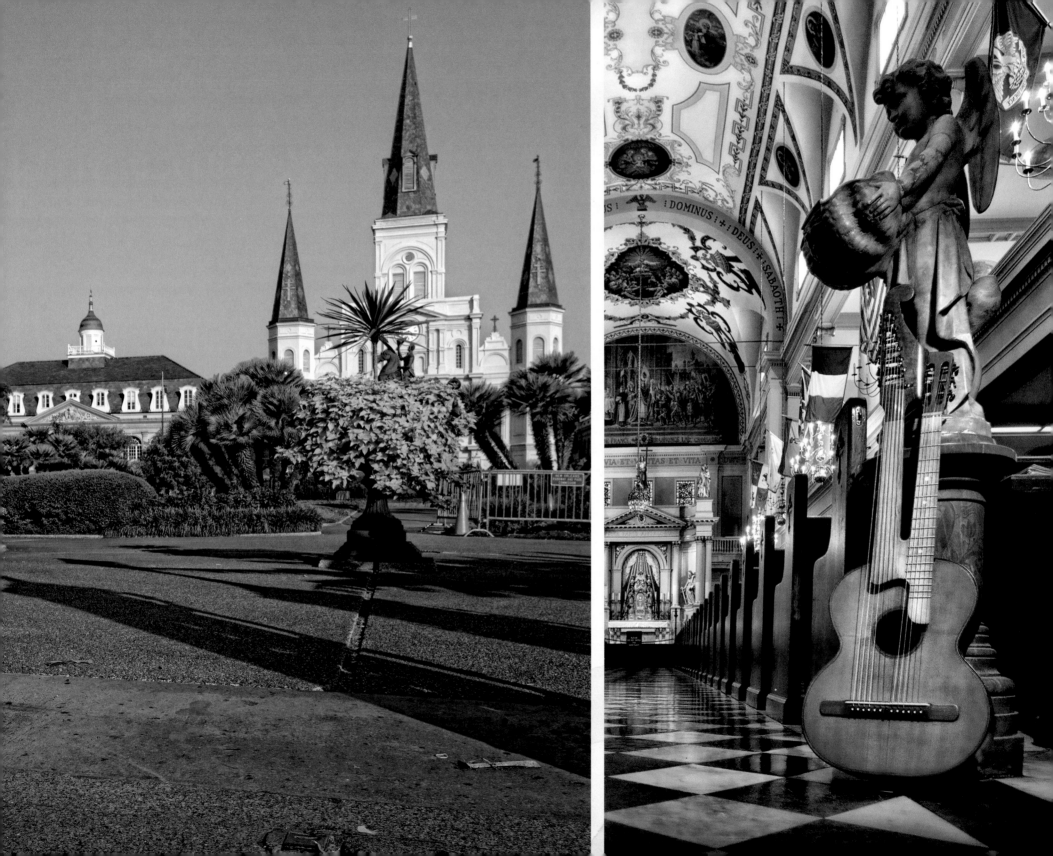

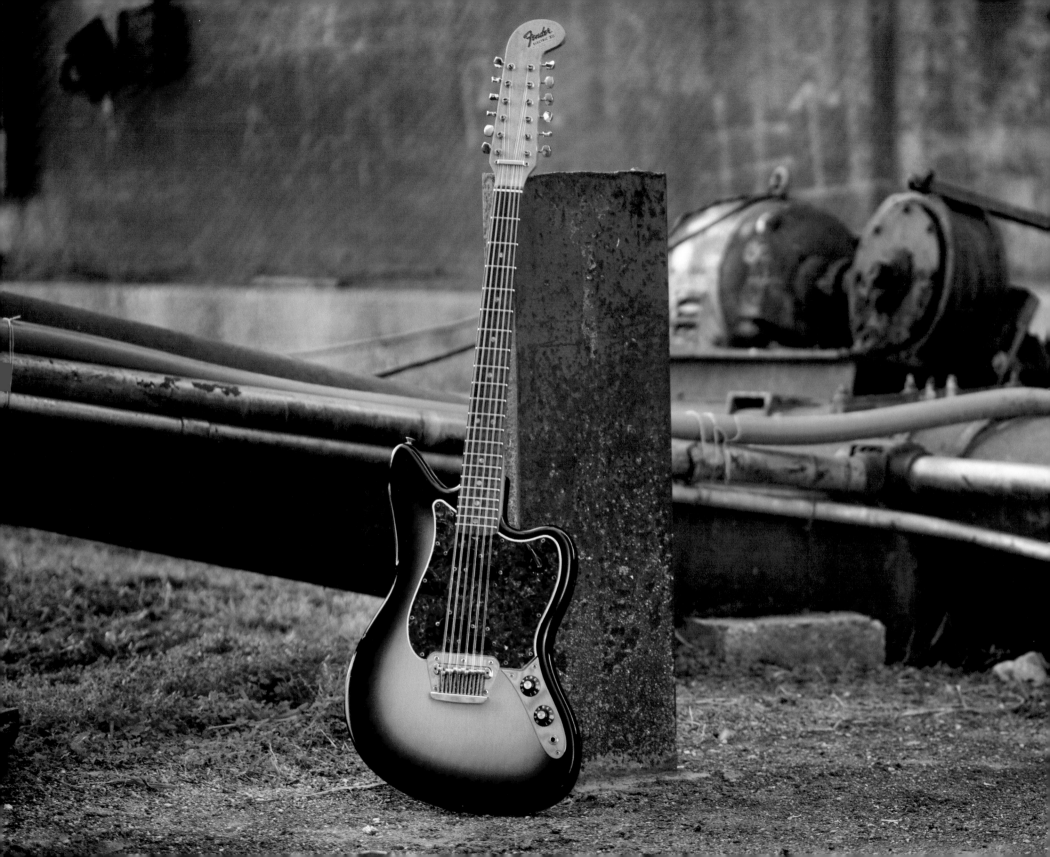

12-String Versus 6-String

1966 Fender 12-String

When many people hear a 12-string, they think of Roger McGuinn and the Byrds. There is such a full-size, jingle-jangle sound associated with it. It creates a nice energy, and I have used it a lot over the years. This was used on many of our early CNN/Sports Illustrated tracks developed in the late 1990s. Later on, I experimented a lot with various 12-string combinations, including this 1966 Fender. One cool idea involved doubling a slightly distorted 12-string "sonic logo" melody with a mandolin.

Outside of an old grain elevator in historic Celina, Texas

61

Amanpour

2005 Washburn Rover

This "mini" guitar has been a lifesaver. Even with a full-size neck, this Washburn Rover easily fits in the overhead, so I often take it along when we present to clients. Sometimes it helps when people can hear what a music logo sounds like in its most raw form. Many times the night before a presentation I am in a hotel, still trying to work out all the ideas I have for a distinctive mnemonic. In 2009 we landed Amanpour for CNN International, mainly because I was playing the logos live. There's something about the vibration of a real live string that always invokes an emotional connection.

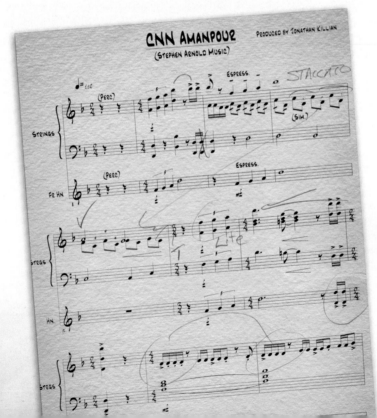

A train yard on the New Mexico–Colorado border
The original sheet music from CNN's Amanpour

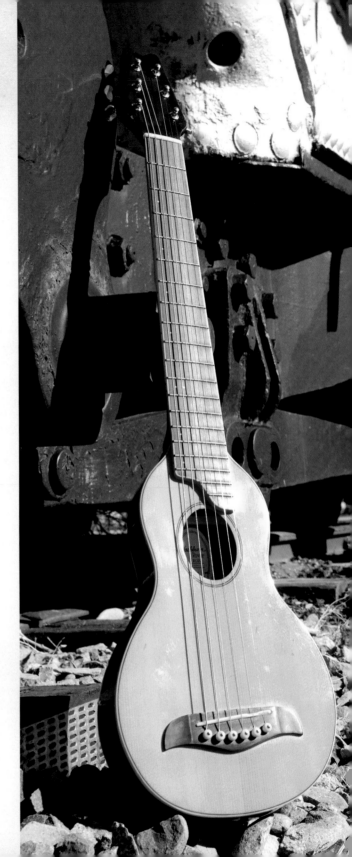

62

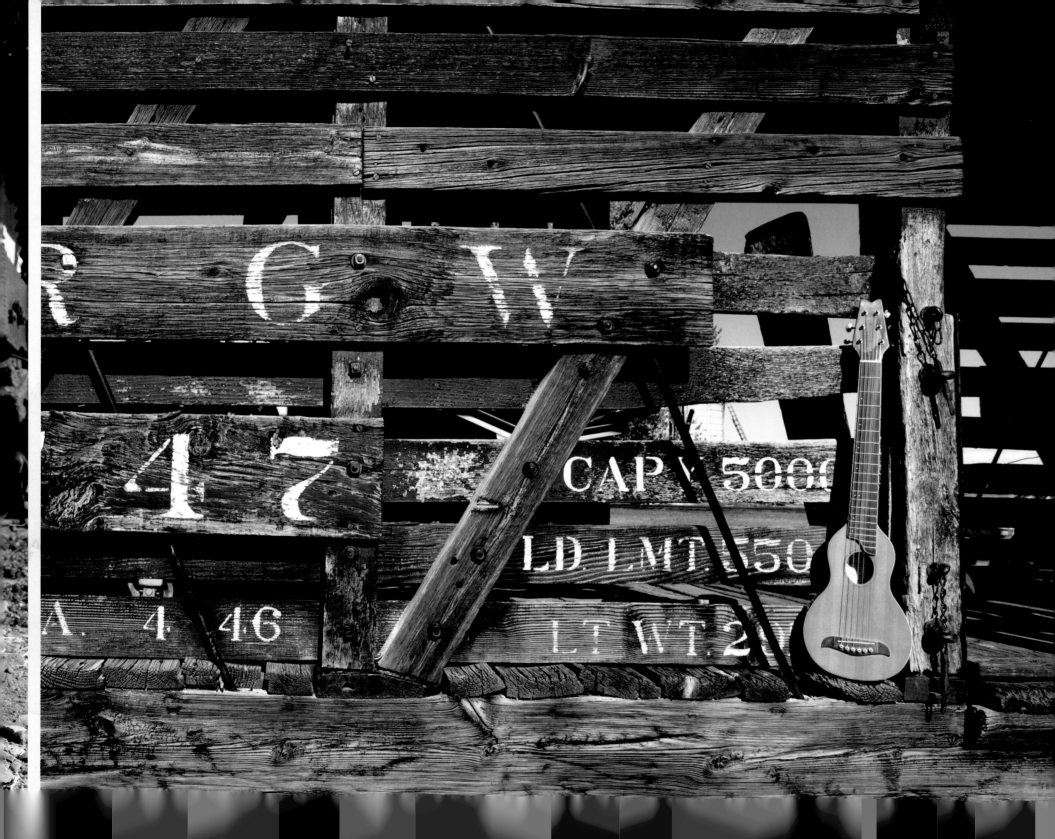

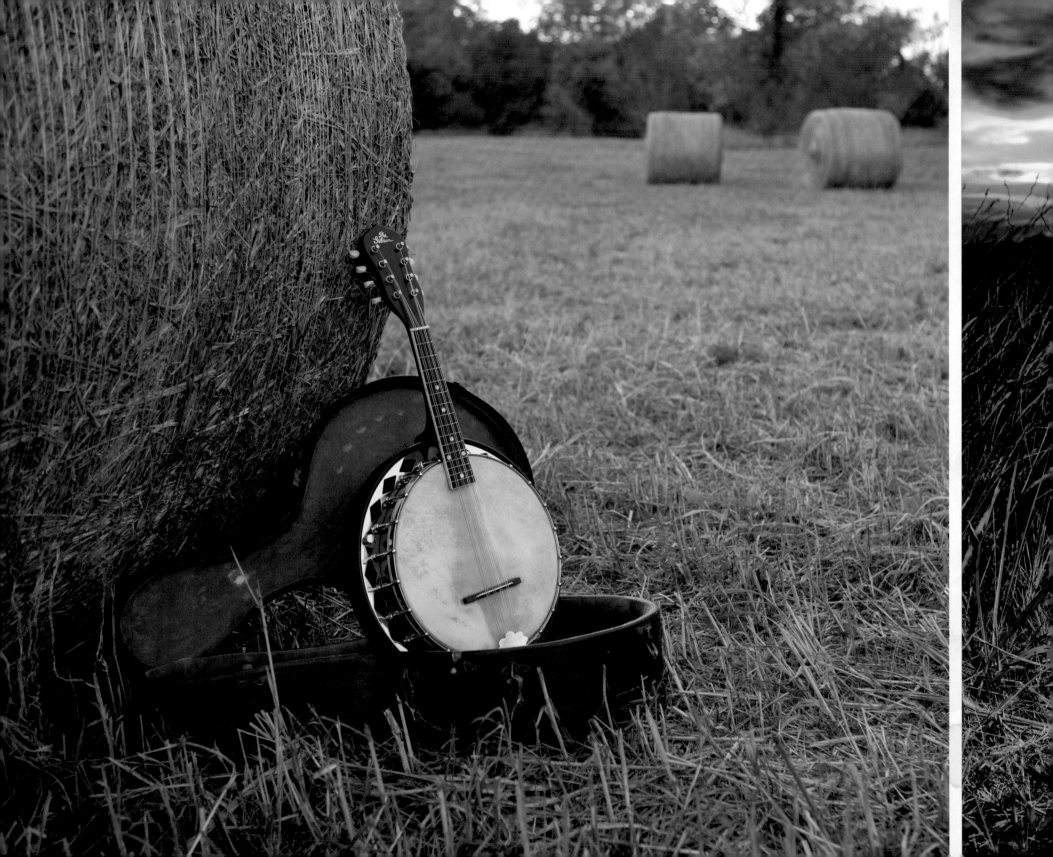

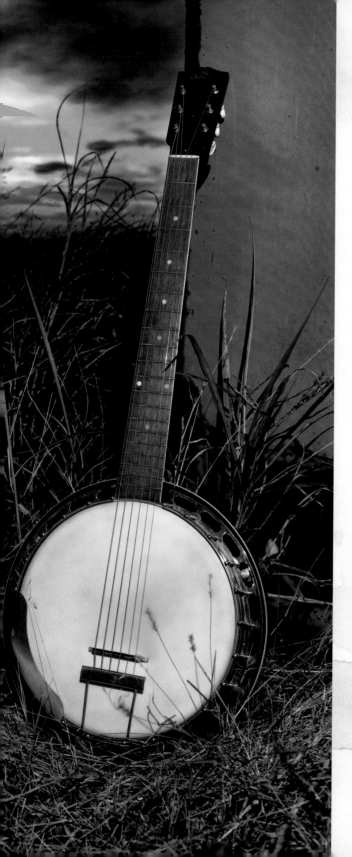

Twin Sons of Different Mothers

Gibson 1928 Banjolin and 1928 Gibson 6-String

McKinney, Texas, just north of Dallas, holds the distinction of having the only jail cell turned into a restaurant and more pawnshops per capita than Las Vegas. I found both of these beauties—which were made the same year—on the same day in two different McKinney pawnshops. What are the odds of that? Sometimes when we open the studio up for client parties, guests will say, "I've never heard anyone play blues on a banjo!" I freely admit Bela Fleck probably has nothing to worry about just yet, but I have a feeling he would flip over this Gibson 1928 banjolin (a mandolin with a banjo body) and 1928 Gibson 6-string.

Just north of Dallas, Texas, on FM 455, on the way to historic Weston, Texas

Transcendent Power of Music

2001 Ibanez Cutaway Classical

Music has the rare ability to transport and transcend. The soft sound of a nylon string takes me away into different musical environments. That was the case when we used this Ibanez classical guitar to develop a series of demo scores for an interesting project with the late Peter Jennings called *ABC News: In Search of America*. The program was reflective in tone, thus the score needed to vibrate with an emotional quality. The deep resonance of the guitar captured the mood perfectly.

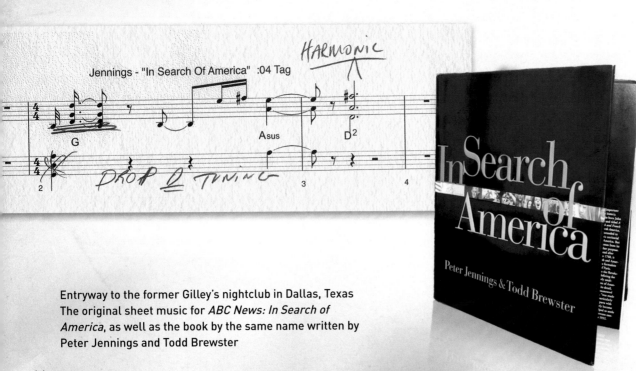

Entryway to the former Gilley's nightclub in Dallas, Texas
The original sheet music for *ABC News: In Search of America*, as well as the book by the same name written by Peter Jennings and Todd Brewster

Indestructible

2007 Martin 000 CXE
Acoustic-Electric

This is my go-anywhere vacation guitar. If we are off on a sailboat or at the beach, it is the best. I think this thing actually floats! I'm pretty sure it's waterproof, too. Once on a camping trip, I left it outside my tent when I went to sleep. When I woke up it was raining and this 2007 Martin 000 CXE laminate/composite body was soaked. I discovered that it sounds better after it's been wet. This is Martin's version of fiberglass.

Old railroad bridge located in North Texas

69

Prime Time

2002 Epiphone Mandolin and 1966 Fender 12-String

Mandolins typically invoke images of Nashville country acts or bluegrass bands huddled together on a small stage. I use them in a variety of projects and genres since it is such a versatile instrument, particularly for percussive and melodic textures. Much of the news music we have created, especially for *CNN Headline News*, requires a sense of urgency, which was traditionally done with violins playing pizzicato—"plucking" the strings with fingers. I found by using muted guitars, like this 12-string, doubled with a mandolin, we could create a more unique and fresh sound. Think of it as a kind of "musical percussion."

WFAA-TV, the Victory Studio, located in Victory Park in Dallas, Texas

Half-and-Half

1996 Martin MTV-1 D-18/35 MTV Limited Edition

This unusual guitar was one of only six hundred such instruments commissioned by MTV commemorating their famous Unplugged series of programs. The shows have featured artists from Alicia Keys and Eric Clapton to Nirvana and Paul Simon, all performing in acoustic settings. The word "unplugged" is actually spelled out vertically on the abalone fret board. I refer to it as my "half-and-half" due to the fact that the treble side of the guitar's back is mahogany and the bass side is rosewood. The result is the guitar's characteristic "blended" sound. To the best of my knowledge, this is the first time different woods were mixed in such a configuration, hence Martin's D-18/28 designation.

Times Square in New York, New York

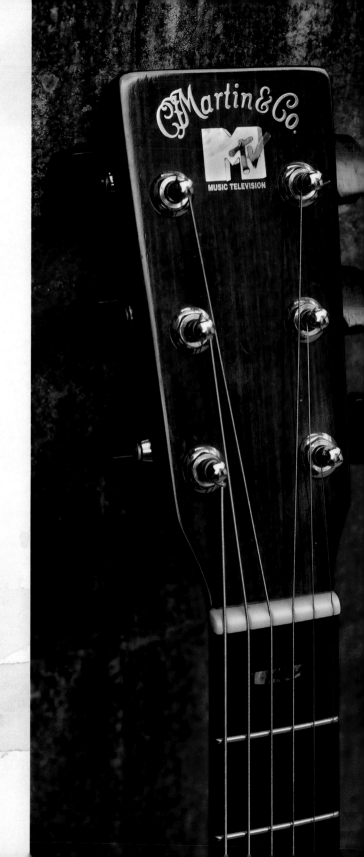

72

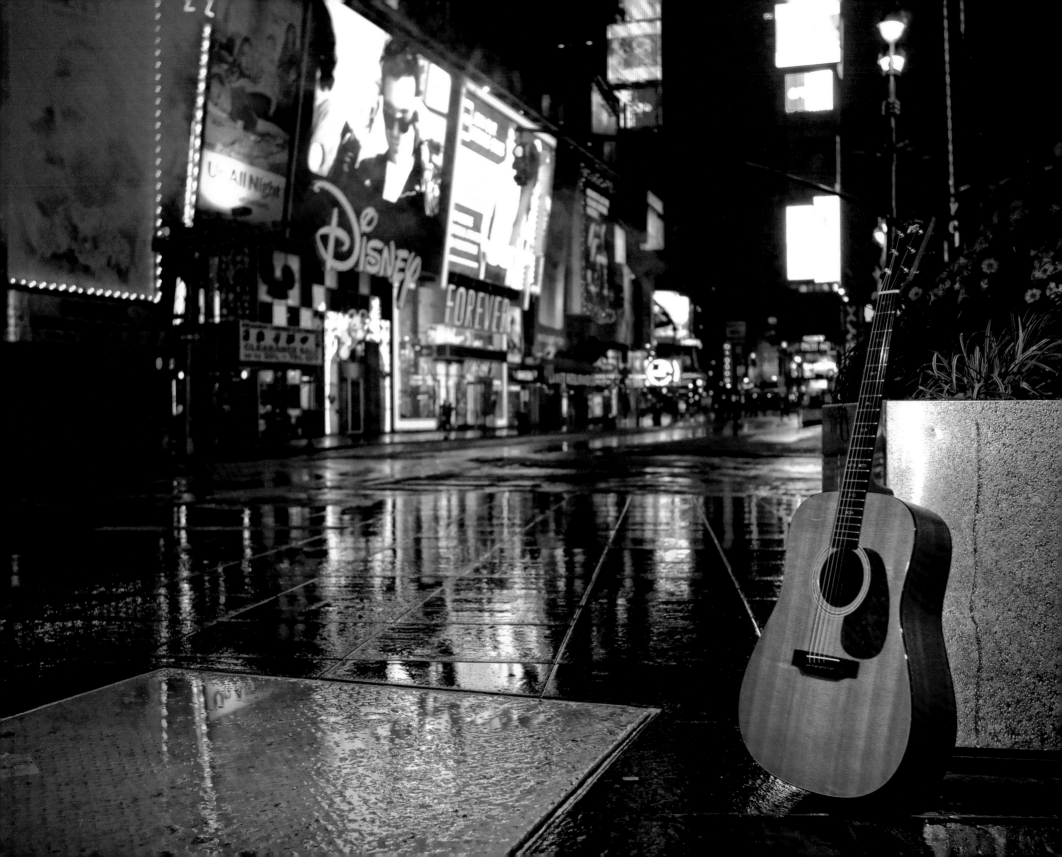

Standing Ovation

1981 Ovation Acoustic-Electric "Al Di Meola" Model

In the late 1970s acoustic-electric guitars became all the rage, especially for some of the hot lick pickin' country and jazz players. I used this 1981 Ovation acoustic-electric Al Di Meola model for a lot of writing in the early 1980s because I could plug straight into the board and not hassle with a microphone or have to worry about feedback. It was perfect for demos. In fact, when ESPN first launched *Baseball Tonight*, I used this Ovation to create all the demo scratch tracks.

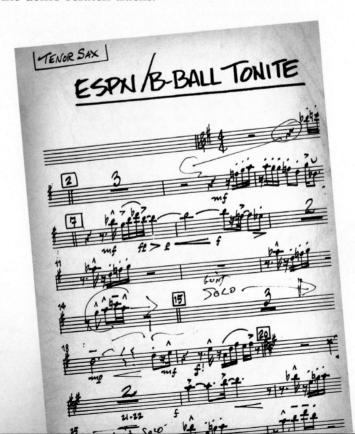

Little League Field at night, located in North Texas
The original score for ESPN's *Baseball Tonight*

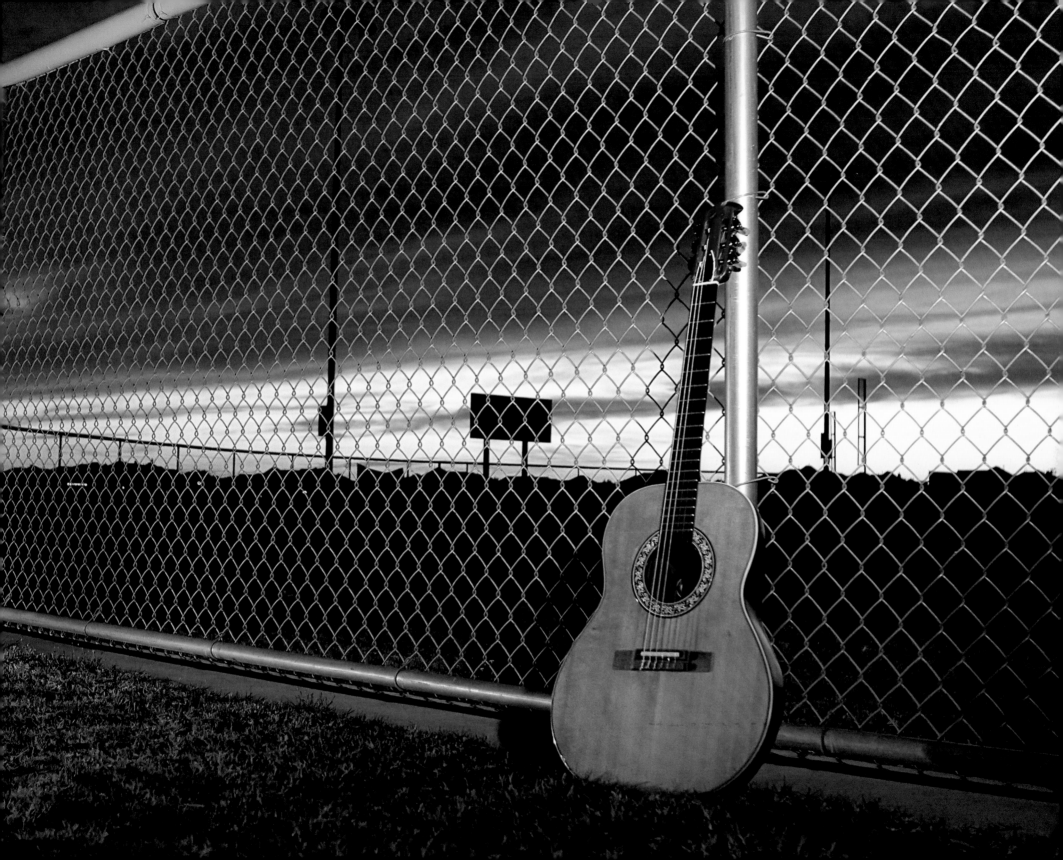

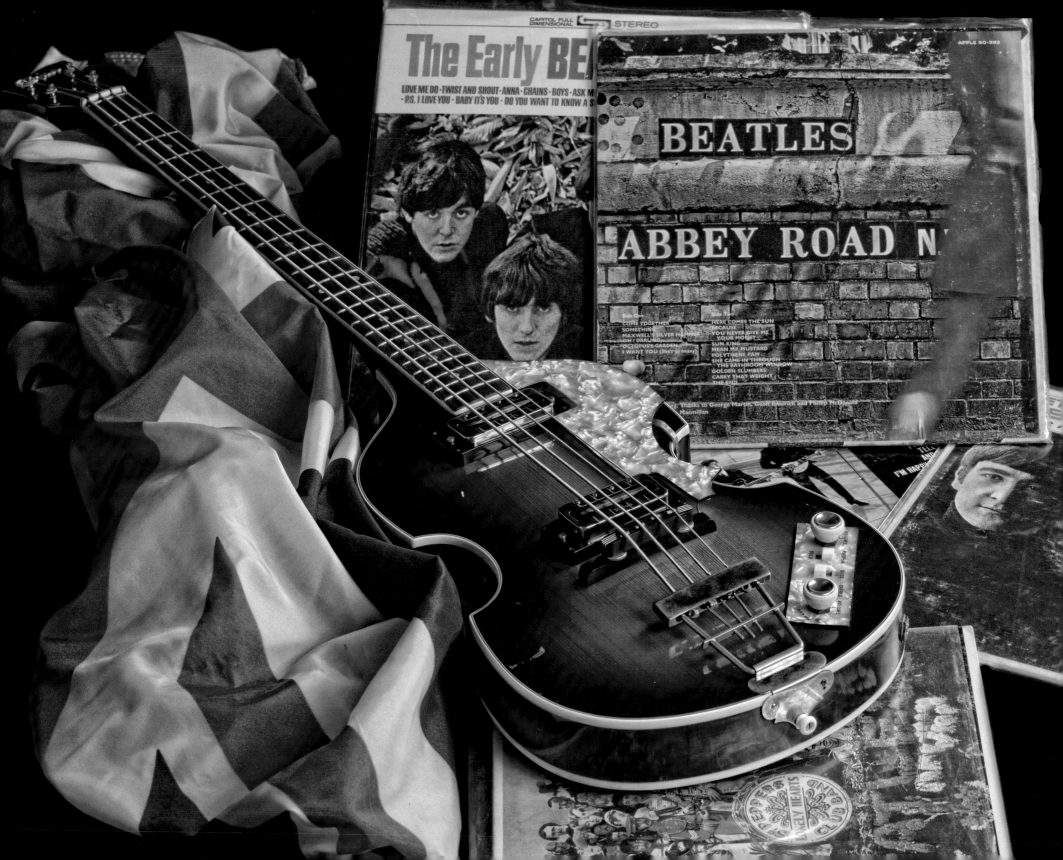

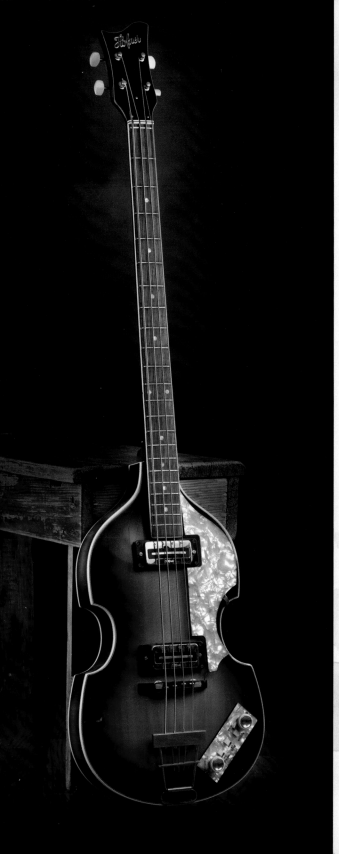

Got to Get You Into My Life

1964 Hofner "Beatle Bass"

Paul McCartney's bright, melodic, and rhythmic patterns have influenced my writing significantly. His Beatle bass—or "violin bass"—was made by the German guitar maker Hofner in 1963. Thus my 1964 edition is so very special to me. Plus mine is a right-handed version, so I can actually play it.

Photo taken in Chris's studio in downtown Frisco, Texas

A Rusty Bolt and String

1950s Silvertone Lap Steel Guitar

The direct descendent of the electric guitar is the lap steel. It started with a rusty old metal bolt found along a roadside vibrating against a guitar string in the hands a Hawaiian boy named Joseph Kekuku. Inspired by the odd tones he heard, young Joe experimented further using the back of a pocket knife, a metal comb, and later a polished bar to fine tune the spine-tingling sound he had discovered. Today he is generally credited as the "father of the Hawaiian guitar." Sears offered a variety of these lap steels over the years in stores and catalogs under the Silvertone label. I love the grimy undertones I get when I plug it in. The Silvertone logo on the headstock is nothing short of an art deco classic in my book. Unfortunately it's not exactly on the wish list in terms of most-requested sounds for clients, but in the right situation there is nothing better.

A blues bar on Beale Street with a live band in Memphis, Tennessee

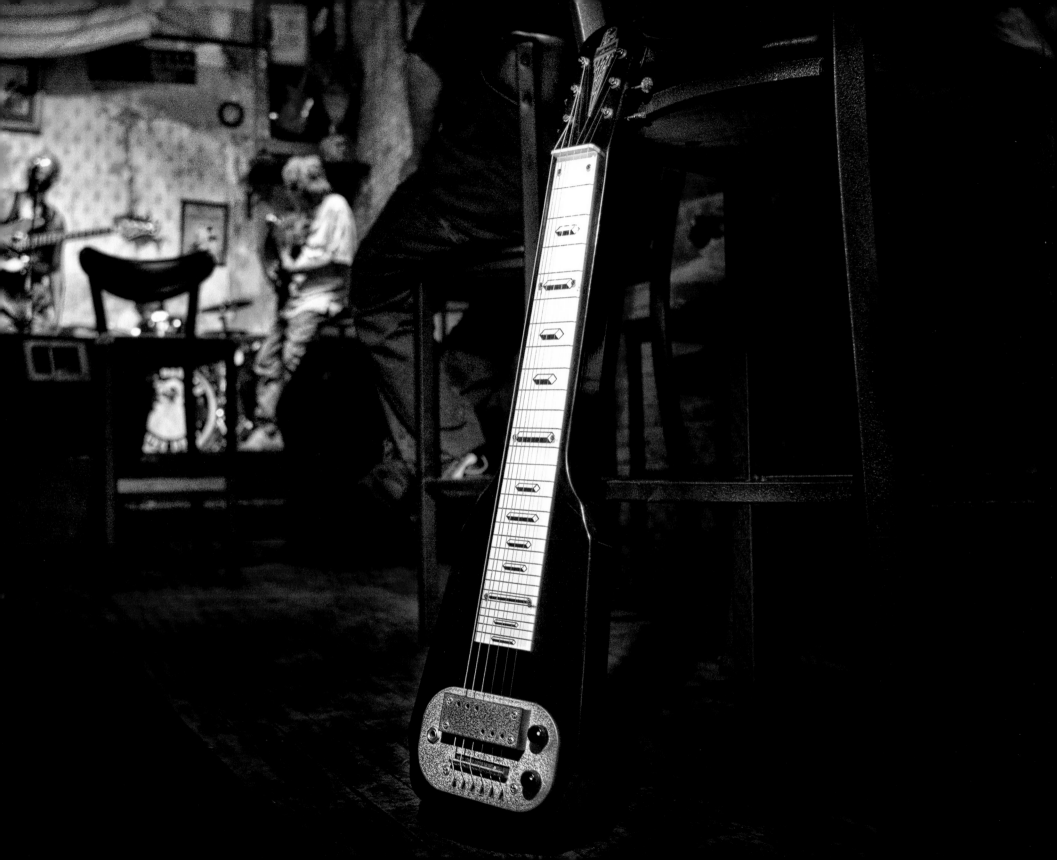

Free Food and All the Music You Can Stand

1970 Guild D-40

On weekends during the mid-1970s my trio had a standing weekend gig at a seedy little bar in the Dunes Inn at Sunset Boulevard and the Hollywood Freeway. The bar would feed us for free, which was a darn good thing since we were all so broke at the time. It was also the place where we could play original material and try to find a home for our music above and beyond the Jackson Browne and James Taylor covers, mostly played on this Guild guitar. As it turned out, from an artistic standpoint this became one of the most important periods of my life. It was here that I learned how to write, debut songs, and enjoy the inspiration and affirmation of a live audience.

The Dunes Inn on Sunset Boulevard in Hollywood, California

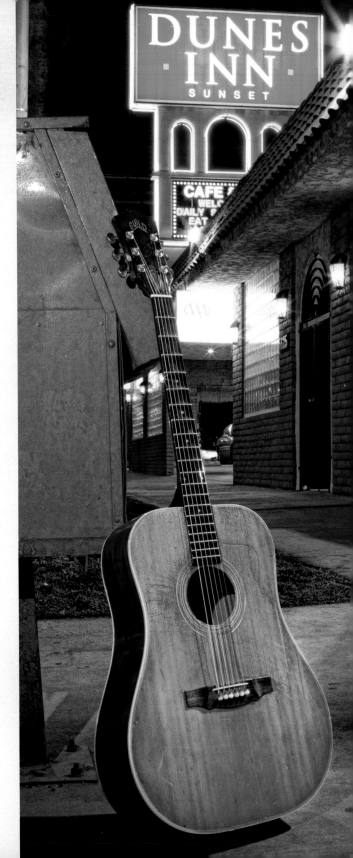

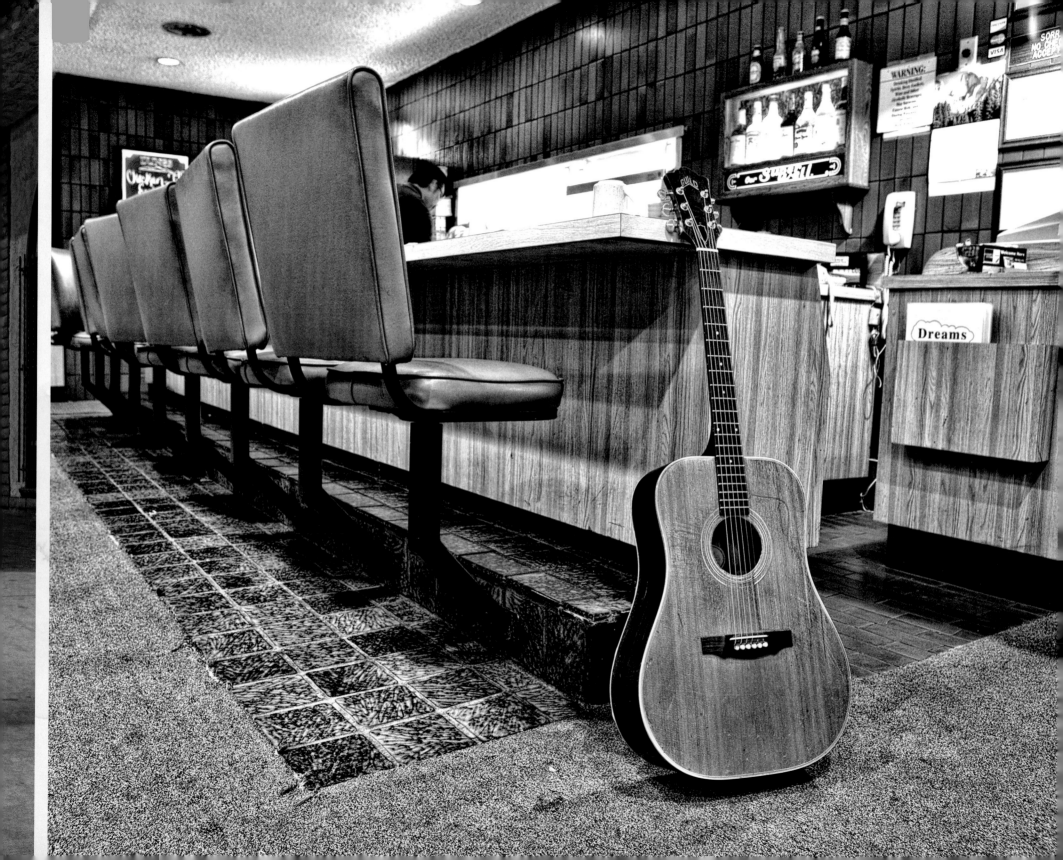

Place of Honor

1893 Neapolitan Mandolin

This one is ultra-special and resides in a place of honor in our home. Since it sits on the mantle I often take it down and start strumming this Neapolitan mandolin, which coincidentally debuted along with the first Ferris wheel at the 1893 Chicago World's Fair. The instrument's bowl-back gives it an unusually deep, warm, rich tone. I find that when I keep instruments sitting out I end up playing them a heck of a lot more. That's a good thing, creatively speaking, because some of my best ideas tend to be the most spontaneous.

On the square in downtown historic McKinney, Texas

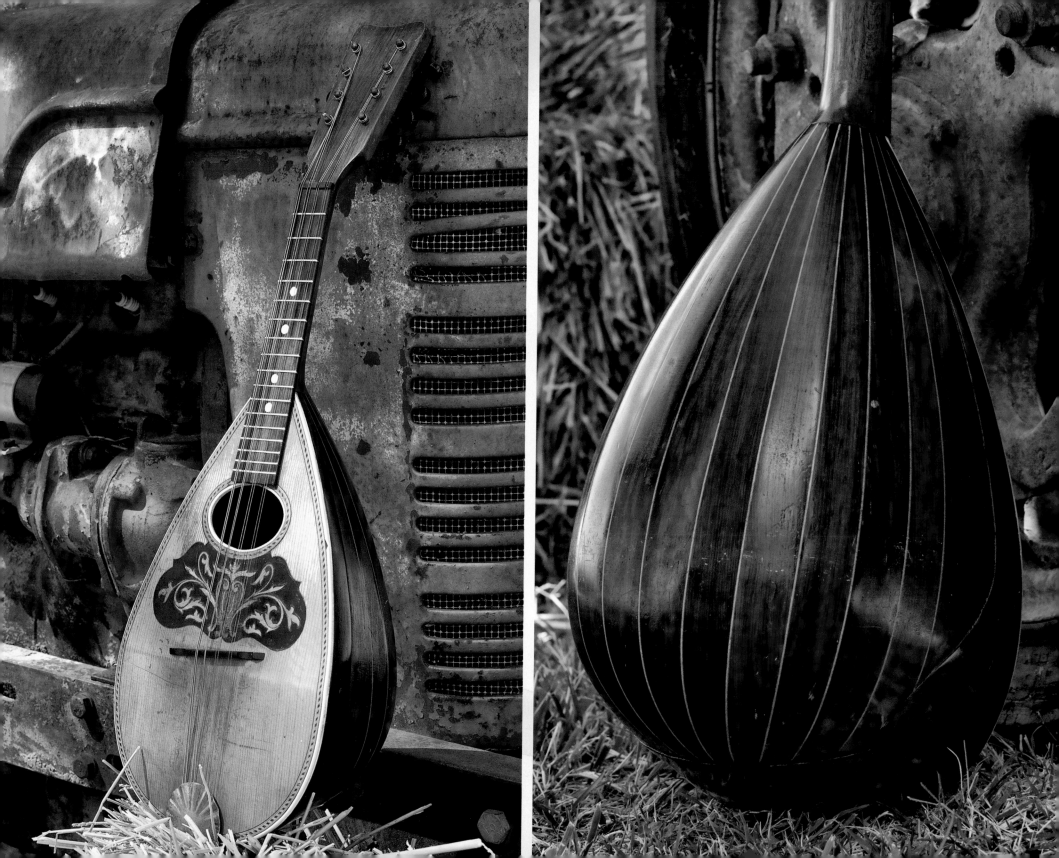

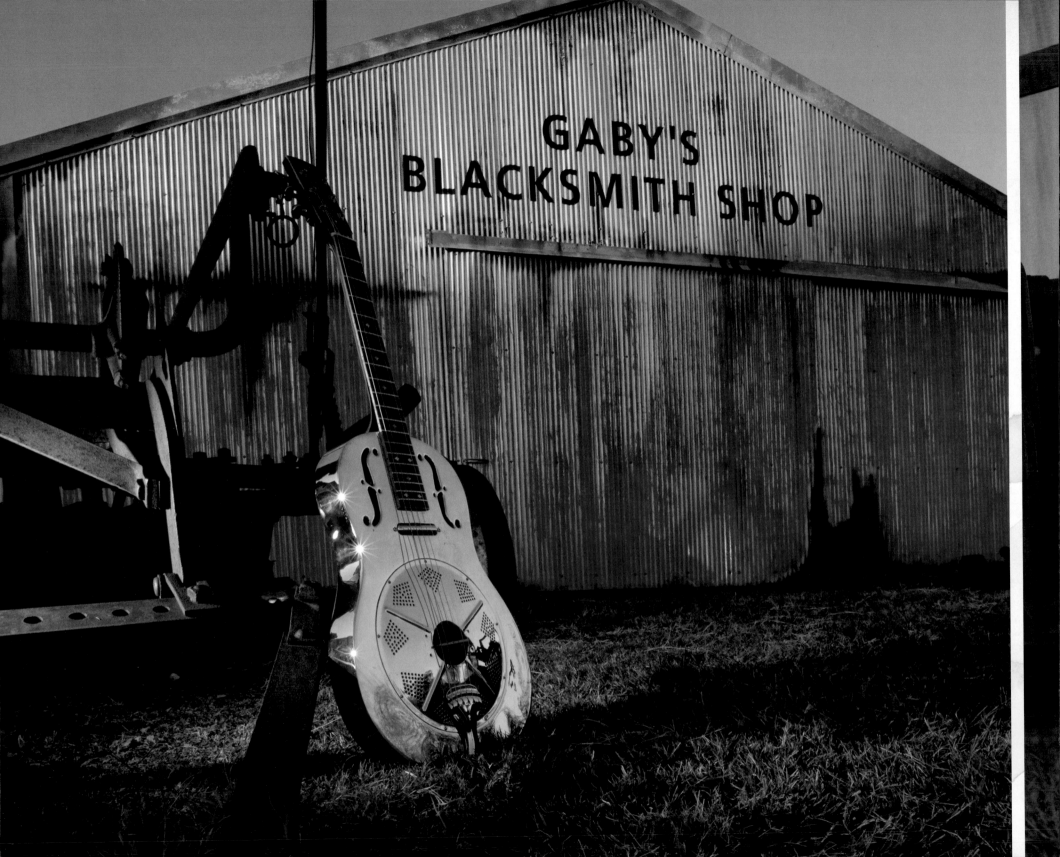

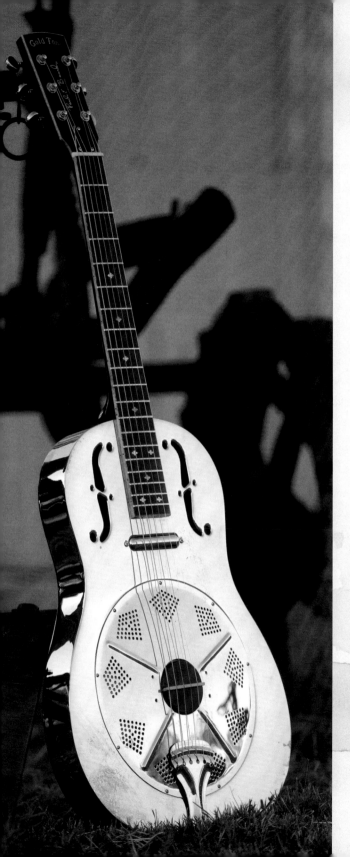

Coyote Lullaby

2008 Gold Tone Resophonic

Can anyone tell me what "resophonic" really means? I have never been completely sure; however, this old school Gold Tone Resophonic guitar with a 12-fret neck rocks. To me it is basically a killer Dobro I can play like a slide guitar. It actually has stereo outs. Run it through two amps with some distortion and some serious paint peels off the wall. On the mesa in Santa Fe, with no electricity, well . . . it's a coyote lullaby.

Replica of a historic blacksmith's shop in Heritage Village in Frisco, Texas

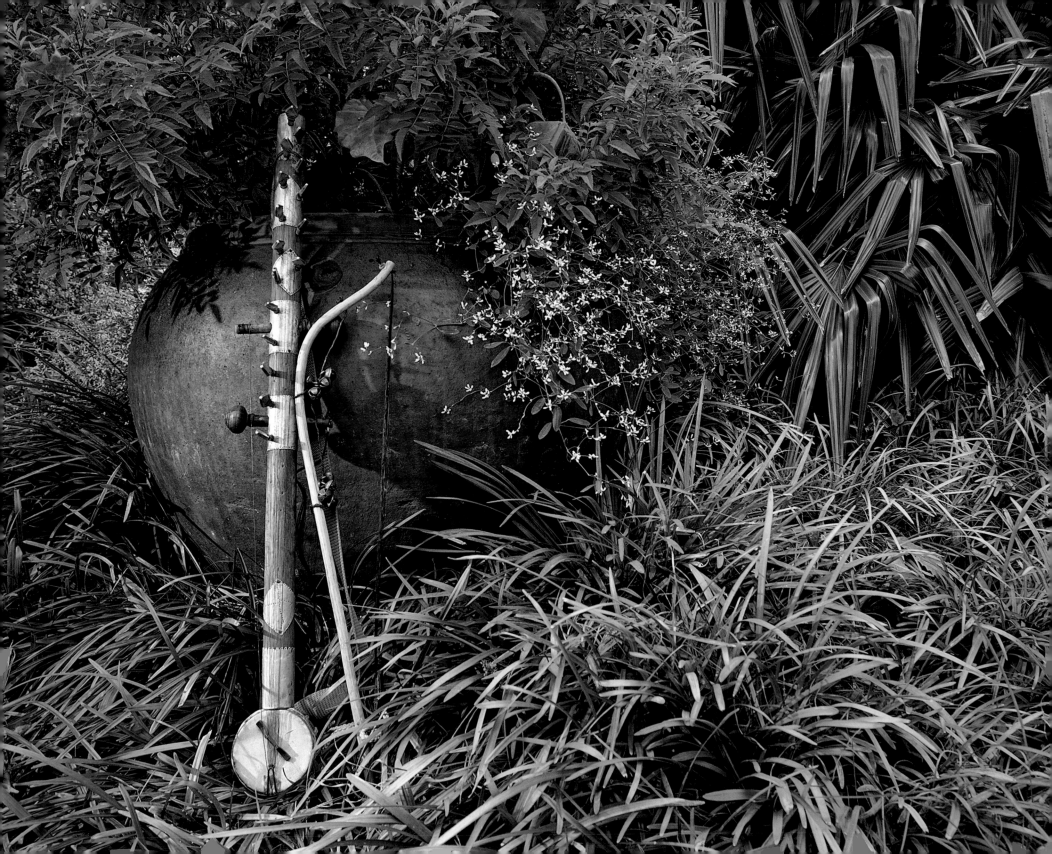

17 Strings, 12 Bells, and a Super Bad Bow

2007 Ravanahatha

We have produced our fair share of international music, and one that stands out in particular was for India TV. Much of what we created was done through Mark Karlen of BDI who, out of the blue, sent me this outlandish instrument he bought in New Delhi called a *ravanahatha*—widely-recognized as the world's first violin. Fortunately no one at India TV ever asked me to play it; otherwise we surely would have lost the gig. One thing I do know: I am probably the only jingle writer in all of Texas with a ravanahatha.

A quaint religious garden in North Texas
Inside the Karya Siddhi Hanuman
Temple in Frisco, Texas
The original score for India TV

87

Billy

2005 Fender Squire Telecaster

As long as I live, I will never understand why top guitarists routinely autograph cheap guitars. In the case of this Fender Telecaster Squire, the guitar actually sounds pretty great. I have done a ton of writing with this one, including promotional pieces for the World Champion Dallas Cowboys, the Stanley Cup champion Dallas Stars, Connie Chung on CNN, and the NBA's Dallas Mavericks. I finally had to stop playing it when I discovered my arm was causing Billy Gibbons's (of ZZ Top) signature to wear right off the guitar.

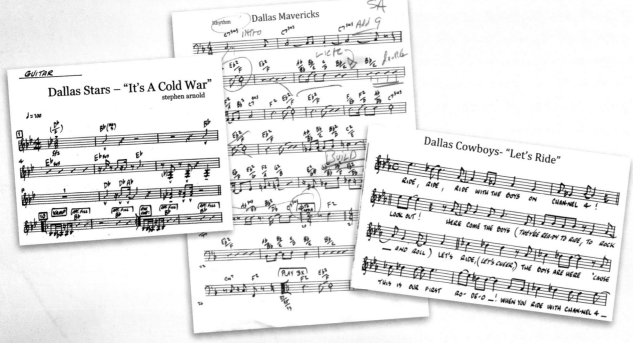

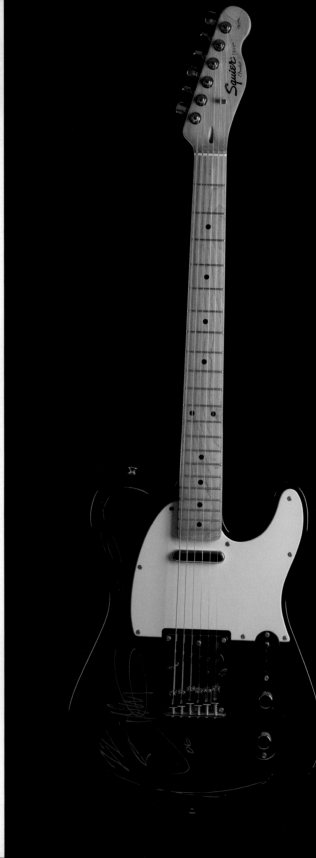

A ZZ Top autographed guitar, shot at Chris's studio in Frisco, Texas
Sheet music for promotional pieces composed by Stephen for
the Dallas Cowboys, the Dallas Stars, and the Dallas Mavericks

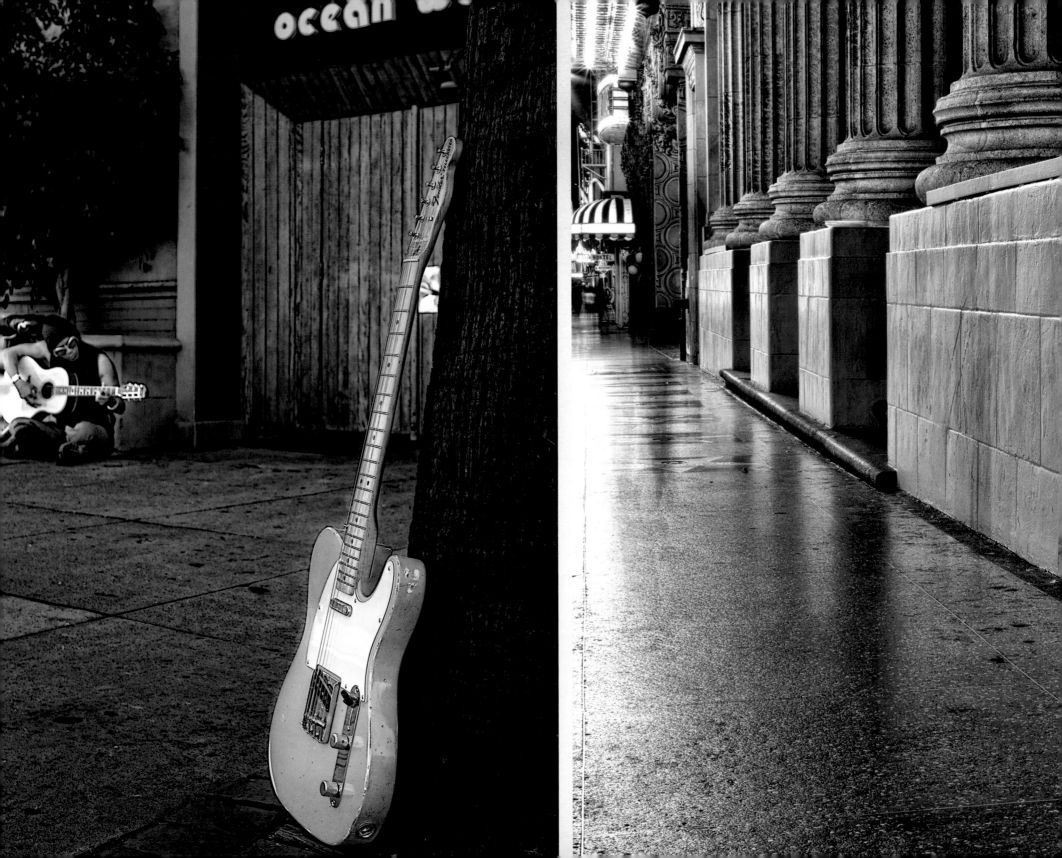

Roll Tape

1969 Fender Telecaster Relic

My first session work as a guitarist was in LA with this '69 Telecaster. I knew my own material backward and forward. But having someone put a chart in front of you and then expect you to nail it after one take was intimidating. I took the lack of callbacks as a sign that I should leave the session work to Dean Parks, Larry Carlton, and a few of the other guys and stick with writing. In the end, it was a valuable experience—one I wouldn't trade for anything. It gave me a much better feel for working with session players later on.

The entryway to Ocean Way Recording, the world's most-awarded studio complex
The world-famous Hollywood Walk of Fame in Los Angeles, California

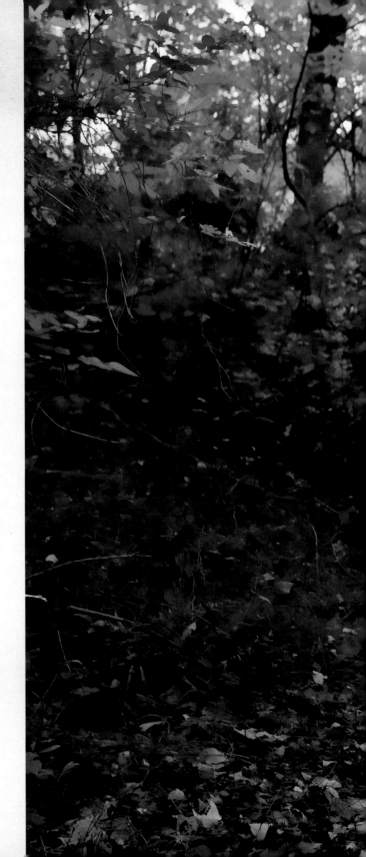

My Turn

Late 1960s Englehardt Upright Bass

When I am alone, jammin' all by myself, it is just cool to have this late 1960s Engelhardt upright bass leaning over there in the corner. I give it a nod and pretend he's letting me take a solo.

Outside Stephen Arnold Music Studio in McKinney, Texas

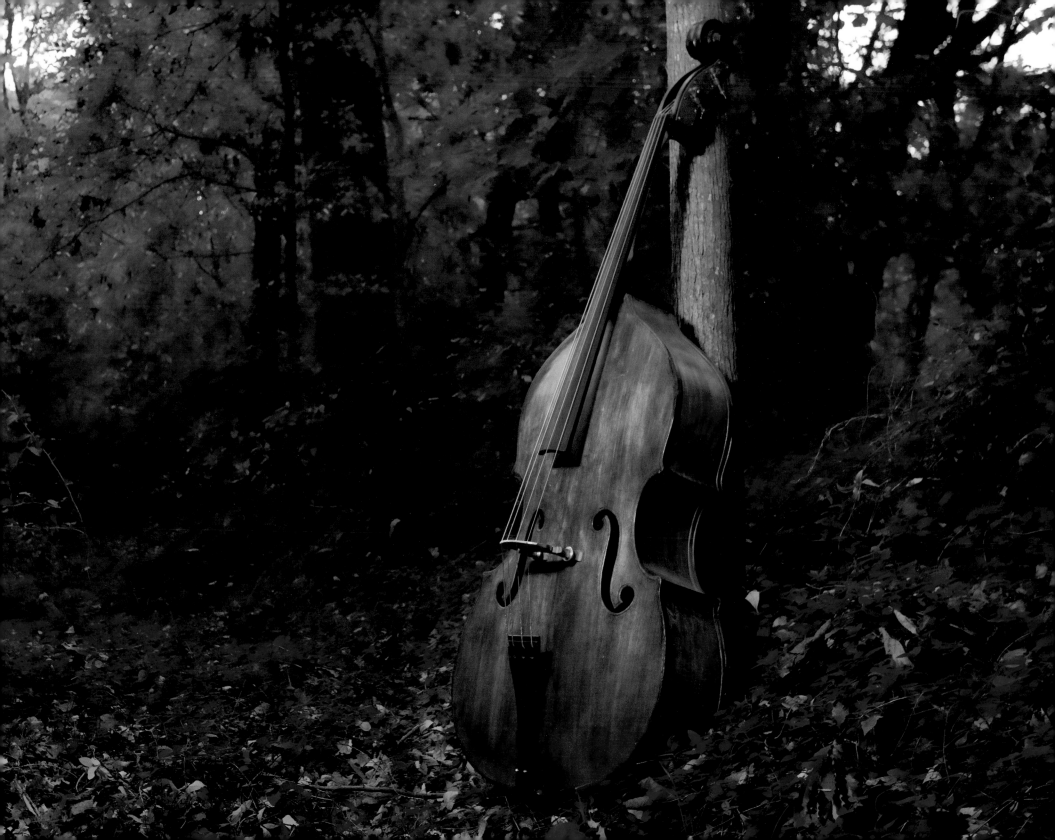

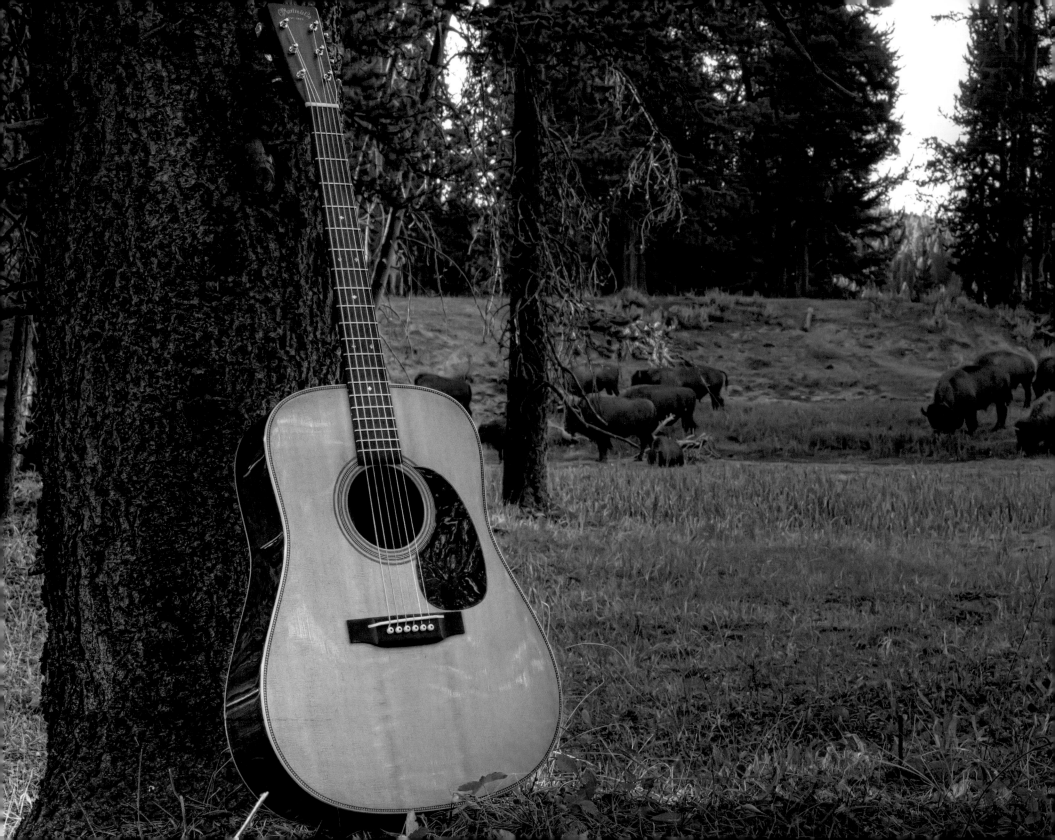

Two-Week "Paid Vacation" in the Middle of Nowhere

1980 Martin HD28V Vintage Dreadnought with Herringbone

One of my final gigs before leaving Los Angeles for good wasn't even in LA. There were so many talented bands based in southern California in the 1970s that it was highly competitive. Good bookings were hard to come by. To make ends meet we would hit the road playing songs like "Tie a Yellow Ribbon" in such unforgettable venues as the Holiday Inn bar in Cody, Wyoming. There was a silver lining: Cody is only thirty minutes from Yellowstone National Park, one of the most beautiful places on earth. "Stay positive," I told the band, suggesting we look at it like we were on a two-week "paid vacation." We checked out geysers, mountains, and buffalo during the day and played "Bad, Bad Leroy Brown" at night. We also logged more than a few hours in the Wild Bill Cody Saloon & Museum after gigs.

Yellowstone National Park, Wyoming

Plug Me Into Something

1994 Ibanez Iceman

I bought this 1994 Ibanez Iceman at a school fund-raiser auction in Dallas. It's autographed by none other than Paul Stanley of KISS. Sometimes you just need a guitar that requires that it be played really, really loud.

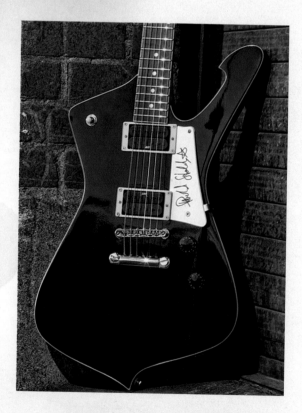

The South Side on Lamar building located in Dallas, Texas

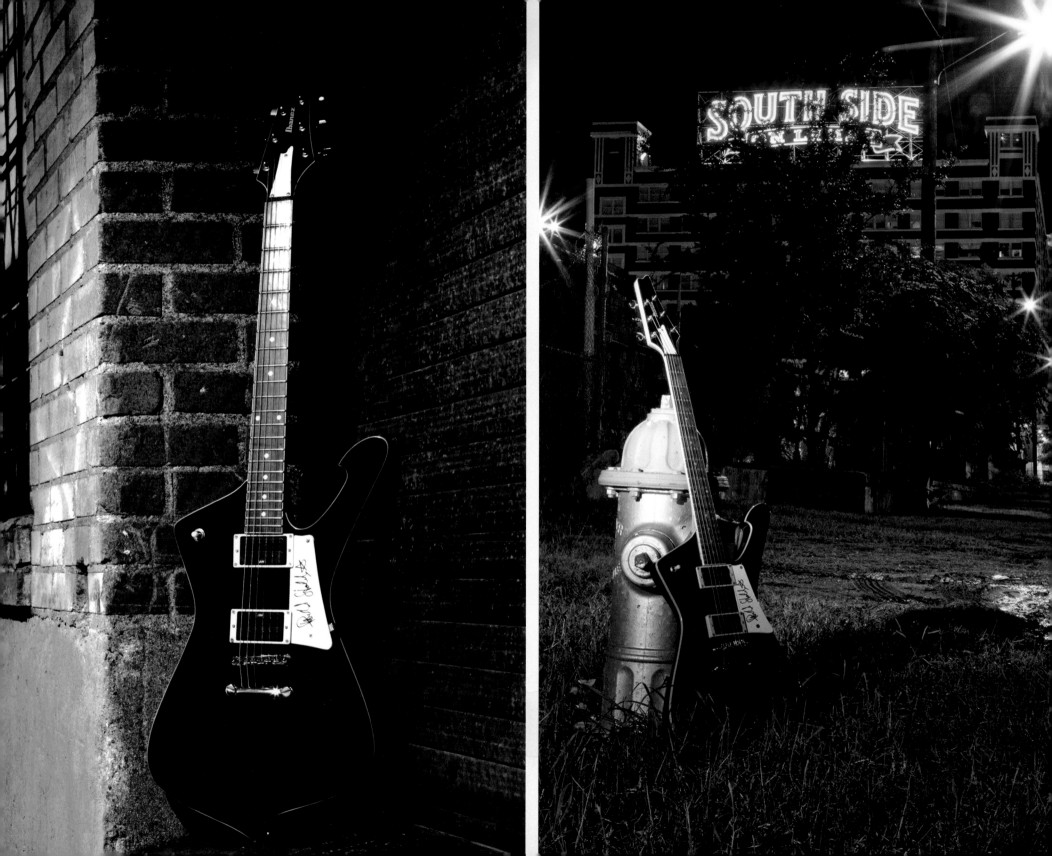

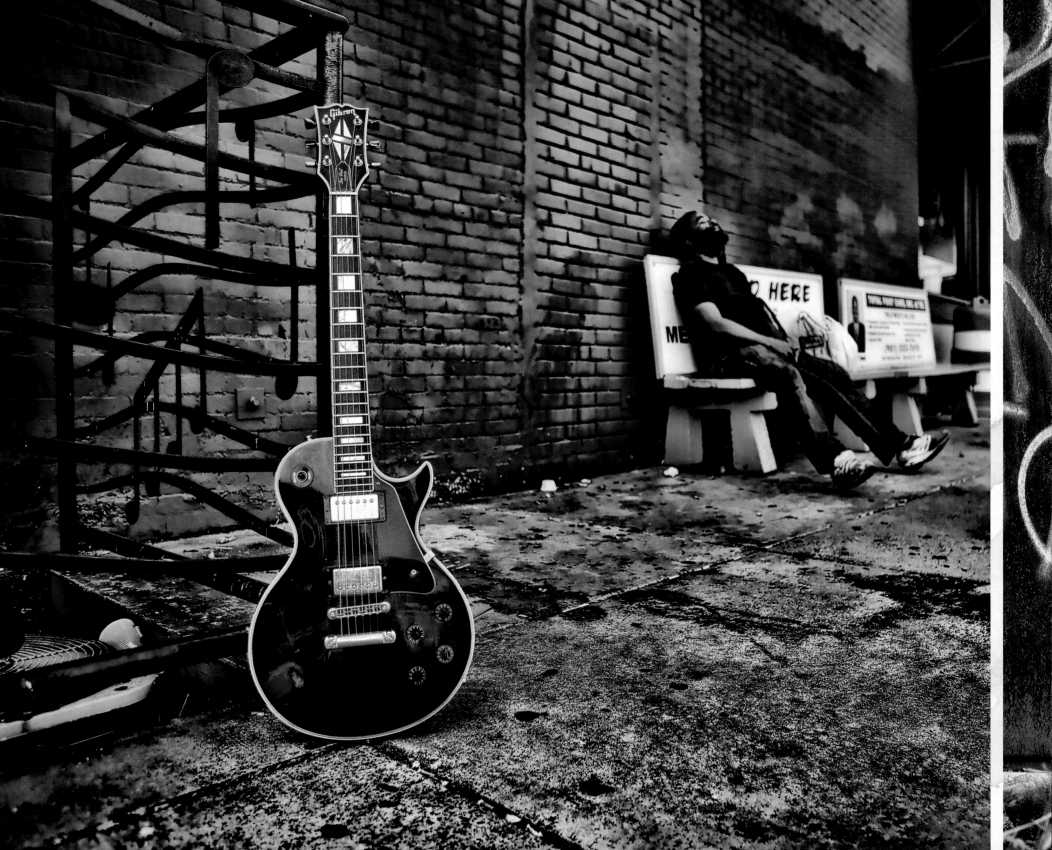

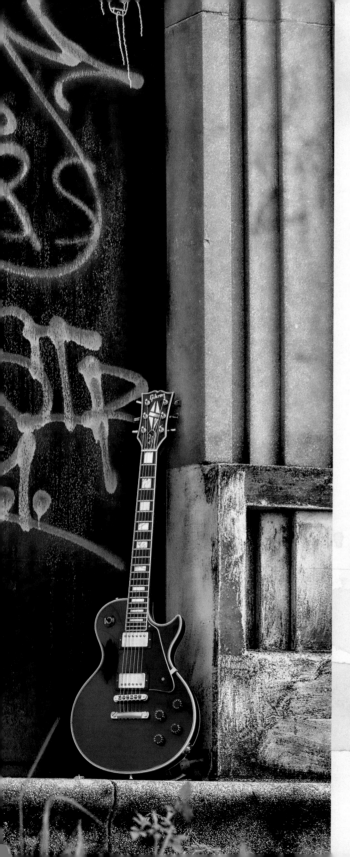

The Log
1980 Les Paul Custom

The Gibson Les Paul is a staple for rock and rollers of nearly every generation, including mine. It was the result of a design collaboration between Gibson and the late jazz guitarist, recording pioneer, and inventor, Les Paul. His original hand-built version was a solid-body prototype appropriately known as "The Log." It had a solid core pine block, whose width and depth was a little more than the width of the fret-board. Gibson reportedly rejected the guitar at first. However, several years later, a second issue was introduced called the Gibson Les Paul Custom. The entire instrument was black and later dubbed "Black Beauty." Although gold was Les's first color choice, he was said to be fond of the black because he thought it made the player's fingers appear to move faster.

A bus stop just off Beale Street in Memphis, Tennessee
An abandoned warehouse along the Mississippi River in New Orleans, Louisiana

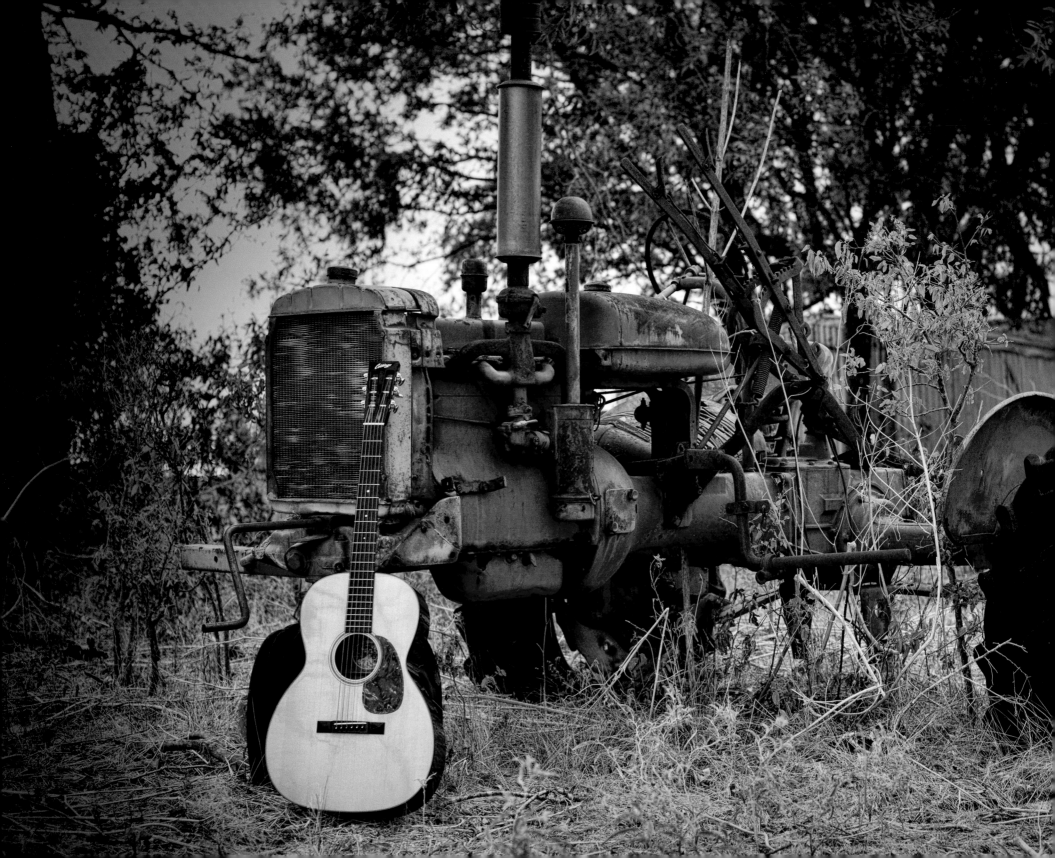

The New Kid in Town

2005 Collings 0001 with Slotted Peghead and Adirondack Spruce Top

A few years ago I was working in our Santa Fe studio with a cowriter, Kevin Afflack. There is a terrific shop in Santa Fe called High Desert Guitars and while there Kevin bought a Collings guitar. I loved the simplicity of the design. However, it was the way the guitar sounded that knocked me out (no doubt Kevin's chops obviously had a lot to do with the sound!). For a long time afterward many of the players I respect, including Kevin, would tell me, "You need to get a Collings." Handmade down in Austin since the late 1980s by a talented luthier named Bill Collings, his guitars are some of the finest acoustic instruments in the world. Well-known artists such as Lyle Lovett, Jerry Jeff Walker, Tim Sparks, Phil Heywood, and Pete Huntlinger all play Bill's guitars. I am an unabashed fan of older guitars, and the last thing I needed was another acoustic. But when I broke down and bought this beautiful slot-head, I was blown away. Made in Texas by Texans, I refer to it as "the new kid in town." And my Collings 0001 has quickly become my "go-to" guitar.

A farmer's field just outside Austin, Texas

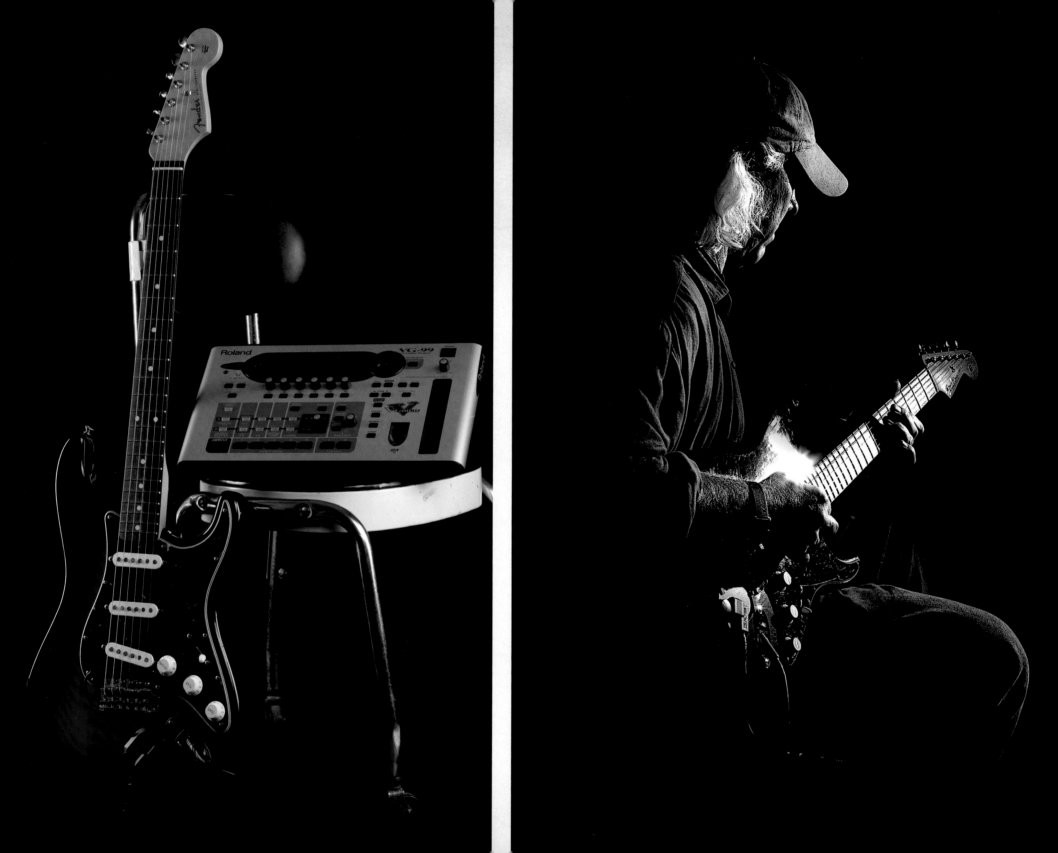

Cut to the Chase

2007 John Mayer Fender Stratocaster and 2007 Roland VG-99

People often ask me, "What comes first, the words or the music?" I tell them, "The deadline." This is my "cut to the chase" set-up and what I use today to write and develop a lot of rough cuts for client approvals. The John Mayer Signature Fender Stratocaster and Roland VG99 are a valuable guitar and amp modeling system that has proven to be a terrific writing tool.

Stephen in his McKinney, Texas, recording studio
Strat and Roland VG-99 photographed in Chris's studio in downtown Frisco, Texas

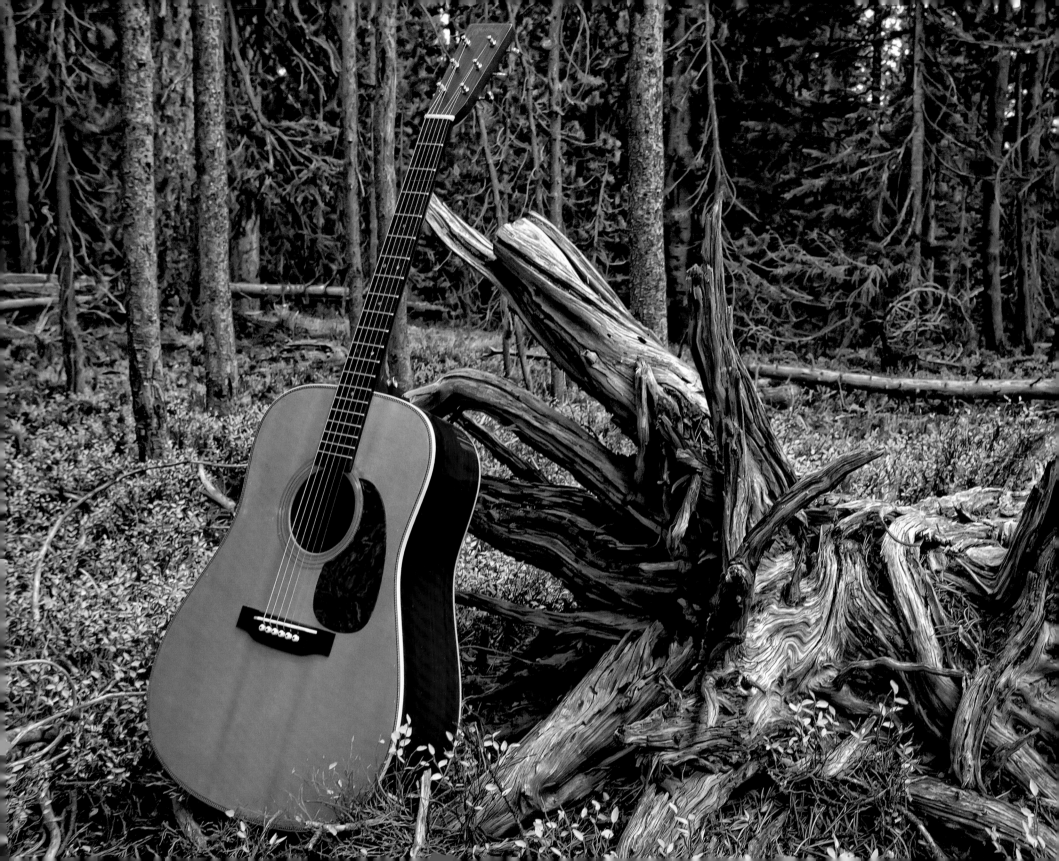

Acknowledgments

Life and work without our friends, clients, musicians, arrangers, creative directors, and corporate CEOs simply would not be possible—and they would be a lot less fun. Trammell S. Crow managed my first band when we were twelve and Lane Lively was my very first songwriting partner. Dan Rather at HDNet had some kind words about my book, and I am so grateful. Steve Miller, who also treasures his first guitar, did too. Paris Rutherford took my simple melodies and helped me turn them into works of art. James Olson made one of my favorite guitars, which inspires me every time I pluck a note or strum a chord. Perry Sook, CEO of Nexstar, runs television stations across the US and believes in the power of sonic branding. Thank you to Rick Booth, formerly of The Weather Channel; he pushed us to "keep it simple" with those four memorable notes of music. David Woo, Pulitzer Prize nominee and senior photographer at the *Dallas Morning News,* for affirming the impact of our visual images. Matthew Nicholl, an incredible pianist and composer, who drove twenty-four hours nonstop to Los Angeles and stood by when Capitol Records said we'd never make it. John Doyle at WFLA, who puts the "creative" in creative director. Pete Northway, my first business partner, who always believed we could get it done. Stephen Swid and Hunter Williams at SESAC. Tom and Betty Crane of Crane Advertising, my first jingle clients. Paul Greely for his creative "sixth sense." David Horslev at CNN Graphics, who organized our photo shoot. Leslie Smith, a tremendous jazz singer and songwriter, for all the help in New Orleans. Bill Manning, for finding "my favorite Martin." Rich Paris and Diane Brenner at ABC Television. Mark Karlen at BDI for the *ravanahatha.* Karen Takata at CBS Entertainment. Michael DeFusco at CBS College Sports. Julie Haaland with *The CBS Early Show.* Jonathan Killian. Mark Wright at CNN International. Bill Galvin and Rolando Santos at *CNN Headline News.* Larry Watzman and Joe Keefe at Comcast. Wayne Nelson. Steven Tyler at *Dan Rather Reports.* Claude Mitchell at ESPN. Vlad Petreanu at GSP Sports-Romania. Lara Ibarra and David Piccolo at The Golf Channel. Dan Farley, Bill Osborn, and Garth Franklin at HDNet. Ritu Dhawan at India TV. Maureen Pierce at Jewelry Television. Marc Greenstein. Bevin McNamara at MSNBC. Robyn Miller at The Tennis Channel. Greg Stroud at FLN (formerly at The Weather Channel). Fran Mires and Geri Howard at Alhurra-Middle East. Bader Qabazard at Al Watan in Kuwait. Marek Loose at TRK-Ukraine. Enrique Valdez Bremont, Claire Chevalier, and Tony Hidalgo at TV Azteca. Jeff Weinstock at Warner Brothers. Paul West, Clay Lorance, Ken Afflack, Bud Guin, Mack Price, Tony Griffin, Gerald Stockton, Adam Wiese, Marty Griffin, Mike Tolleson, Michael Perlstein, and Alden Wagner. My publishing team at Brown Books Publishing Group—Cynthia Stillar, Jessica Burnham, Auburn Layman, and Omar Mediano.

About the Photographer

Chris Fritchie is an award-winning photographer and member of the Professional Photographers of America. With over 50 magazine covers, and over a thousand published images, Chris is unique in today's world of photography.

Photographing editorial and the demands it brings has allowed him to develop a style of capturing great images on the fly.

Providing portrait services to North Texas, as well as editorial and advertising, have allowed Chris the opportunity to photograph just about every situation possible. His love for photography was born of a need for a portfolio for his landscape business in East Texas many years ago.

Whether capturing images for a story on fine dining or musicians such as Vince Gill, Jack Ingram, and Charlie Robison, the style of photography Chris brings is always fresh and exciting

Chris and his studio are based in the Dallas–Fort Worth area and he is the proud father of two beautiful daughters, Abby and Becca.

About the Author

Often referred to as the most heard, least known composer in America," Stephen Arnold's compositions can be heard daily in more than 100 million American homes and around the world on broadcast and cable networks, and in commercials and film projects.

Originally from Indiana, Stephen grew up with the dream of becoming a rock musician and songwriter. He chased that dream to LA in the late 1970s but eventually landed near his family in Dallas, where he wrote his first television jingle later that same decade.

A pioneer and early evangelist of sonic branding—the blending of original music compositions with tones and special audio effects to create a distinct auditory signature—Stephen has created numerous Emmy, Addy and Promax Gold award-winning musical compositions.

His compositions include music for CNN, ABC News, CBS, The Weather Channel, CNN HLN, the National Geographic Channel, FOX, HBO, Time-Warner, TNN, The Golf Channel, ESPN, as well as major advertisers including McDonald's, Honda, Pizza Hut, Hershey, Kodak and most recently many international sonic brands for Kuwait TV, India TV, Romania, Slovenia, and Azteca TV.

Stephen divides his time between Dallas, Texas, and Santa Fe, New Mexico.

> "Next to the Word of God, music deserves the highest praise. The gift of language combined with the gift of song was given to man that he should proclaim the Word of God through music."

—Martin Luther